PROFESSIONAL SECRETS FOR
Photographing
Children

2nd Edition

Douglas Allen Box

AMHERST MEDIA, INC. ■ BUFFALO, NY

Published by:
Amherst Media, Inc.
P.O. Box 586
Buffalo, N.Y. 14226
Fax: 716-874-4508

Website: www.AmherstMedia.com

Publisher: Craig Alesse
Senior Editor/Project Manager: Michelle Perkins
Assistant Editor: Barbara A. Lynch-Johnt

ISBN: 1-58428-063-8
Library of Congress Card Catalog Number: 2001-132051

Printed in Korea.
10 9 8 7 6 5 4 3 2 1

Dedication and Special Thanks

I would like to dedicate this book to my sons, David and Derrick. Although I had already been photographing children for several years prior to their birth, I don't think I knew why children's portraits were so important until I had children of my own. Derrick and David were usually willing subjects and let me try out new techniques on them. They taught me one very important thing: the love between a parent and a child. Understanding this relationship has made me a more sensitive photographer. Portraits are memories, and I wouldn't trade my memories for anything!

There are a lot of people to thank. First, I'd like to thank my dad, who got me started taking pictures, loaned me equipment, and bought me my first camera. His best photographic advice was, "When taking pictures on vacation, the photographs that have the most meaning are those with friends and family in them. Don't worry about getting great shots of the animals at the zoo or the magic castle. Concentrate on images that include your children. Those are the ones that will create the best memories."

I also want to thank all of the instructors and teachers who have unselfishly shared their photographic knowledge. They took me from taking pictures to making portraits. A special thanks to Les Peterson, Broken Arrow, OK, for sharing his portrait guidelines and concept of "playtime" with me. Thanks to the parents who trusted me to capture their special memories. But most of all, I want to thank the children. They make me look good. They are so beautiful and special. They have kept me young at heart and taught me how to enjoy the wonderment of life!

Doug Box with wife Barbara Box. Photograph by Jack Holowitz.

SECTION 3
WEDDING IMAGES

SECTION 4
CHILDREN'S STORYBOOK

APPENDICES

Photographing children can be fun, if you know the secrets. It can also be financially and artistically rewarding. I consider children young adults. When talking to them, I show respect not only for their feelings, but also for their intellect. Children are much smarter than they let you think. I will admit, though, it does help to be a child at heart. To work well with kids you should enjoy playing games and pretending. You should like being silly and laughing a lot. If you don't enjoy all of these things, that's okay, but get someone in the camera room who does. Then you can hide behind the camera, be quiet, and take the photographs.

Kids just want to have fun. If you can make sure that all of the children who come to you for photographs have fun, they will want to come back. There

I'LL SHARE THE TRICKS OF THE TRADE THAT I HAVE LEARNED FROM YEARS OF EXPERIENCE.

are lots of different kinds of children: shy, timid, outgoing, silly, serious, and so on. When photographing a child, the photographer's job is two-fold: he or she must evaluate the subject's

personality type, and decide how to bring that unique personality out in a fun way.

In this book, I'll share the tricks of the trade that I have learned from years of experience. So much can be said about every image! In this book I will cover techniques for metering, film selection, posing, placement of lights, clothing selection, and more. In flipping through these pages, you will also find helpful discussions on everything from background selection to props to shutter speed and psychology. The clear, simple illustrations that accompany many of the images will show you exactly how the lighting was set up for each of these beautiful images.

This book is divided into several sections. The first section deals specifically with images shot in the studio. The second moves on to dis-

cuss images taken outdoors and on location. We will cover tips and techniques that will help you to create unique wedding images that any client will cherish. Finally, I will present you with ideas that will help you to create a highly personalized, exciting package for your client through the development of a storybook format.

In reading this book, keep in mind that photography is one of the greatest professions in the world. As a photographer, you have been given the unique ability to touch people and create memories in ways that people in other professions can only imagine. Remember, the ultimate goal is great photography (and greater sales). I believe that the images and discussions on the following pages will help you to achieve those goals. Good luck—and be silly!

1

STUDIO
IMAGES

Two Children in White

POSE. A crossed-leg pose is always cute for little boys. If boys have pockets, use them. With one hand in the pocket, you have one less hand to worry about. The girl is in a simple sitting pose, but notice how nice it is with her feet crossed. When posing two children of different heights, I usually seat the taller child and let the shorter child stand. The ultimate goal here is to have their heads be at different heights, but not too far apart.

PROP. This Louis XV chair is a prop from American Photographic Resources (you can contact them via the resources section in the back of this book). I think it is a great prop for children. Its elegant lines and white/off-white color scheme make it very versatile.

BACKGROUND. The soft pastels on an off-white base of this painted background lend a nice, soft feel to this image. This particular background is available through Les Brant (see the resources section on page 122).

PHOTOGRAPHY. A window to the left of the camera provides the light for the image. I placed a reflector to the right of the camera, slightly in front of the subjects. This allows the light to wrap around them. The 120mm lens on the Hasselblad is great for photographing in small rooms. It gives you all of the benefits of a telephoto lens: separation from the background, lack of distortion of the subject (which is sometimes characteristic of normal or wide angle lenses), and the ability to move back from your subject and make them feel more at ease. Because it has a slightly shorter focal length than the popular 150mm, you can take full-length portraits, even in fairly tight quarters. It will also focus closer than the 150mm. The film used was Kodak PPF.

PSYCHOLOGY. If you act silly with children you can sometimes get very natural, happy expressions. I ask them, "Are you married?" or ask boys, "Is your name Mary?" Another trick that always seems to work is telling the children to "Give me five!" When they do I say "Ow!" and pretend it hurts. I don't know why, but most children find this funny. At first it surprises them, then every time they give you five they laugh.

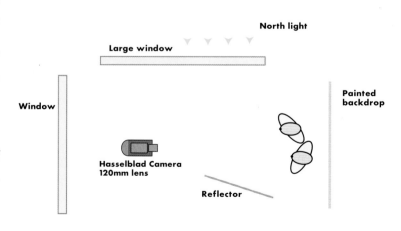

North light

Large window

Window

Painted backdrop

Hasselblad Camera
120mm lens

Reflector

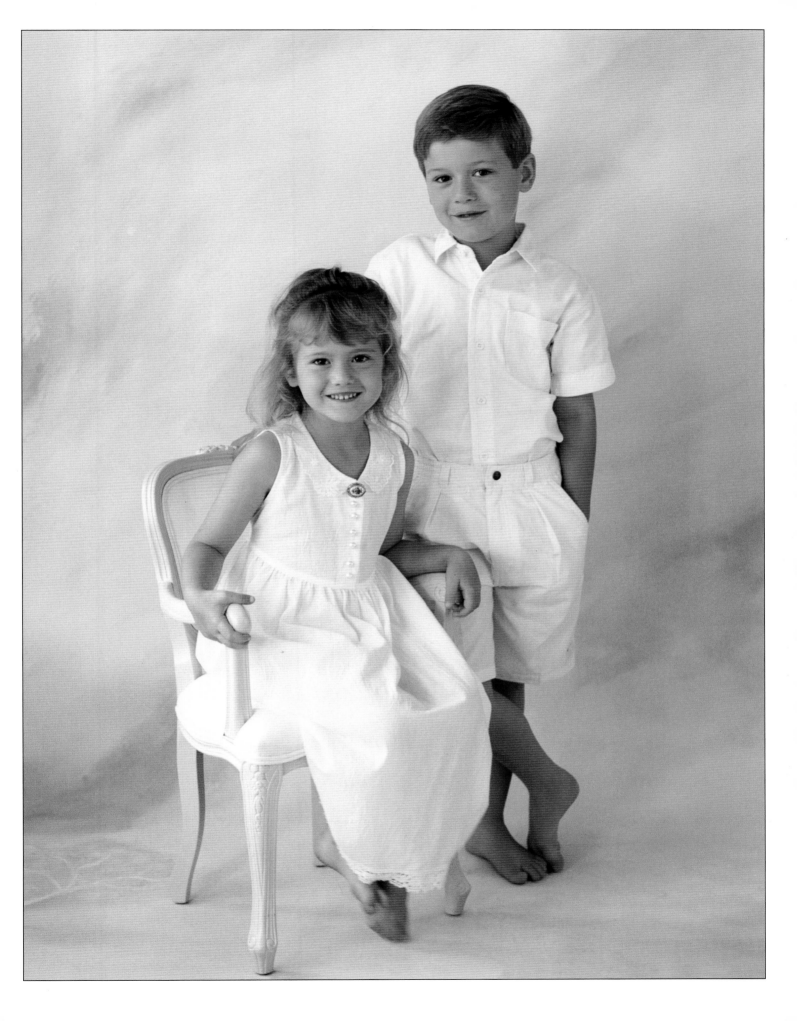

POSE. This is the basic dance pose. I like to use it when I'm working with children, and in prom or engagement sessions. As you can see, using this pose here resulted in a full face of the little girl

THE PROBLEM MOST PEOPLE HAVE WITH A FILL LIGHT IS THAT THEY USE TOO MUCH POWER.

and a ⅔ view of the older girl. When I set up this pose, I had to decide whether to raise the small girl up to the older girl's height to bring their heads together, or to keep them at their real heights. I chose the latter.

PROPS. The girls had their dresses and hairpieces for a special party. They make for a nice feel in the portrait.

BACKGROUND. To make this window, I purchased a set of frames used for double-glazed windows. I built a frame for them to rest in using 1" x 6" boards. A set of sheers were hung in front of the frames. I then hung cur-tains to create the appearance of a real window.

PHOTOGRAPHY. This is one of the few photographs in this book that uses a fill light. Most of the time I use a reflector for fill. I used it this time to help lighten the curtains. The problem most people have with a fill light is that they use too much pow-er. This causes the photo-graph to be overfilled, giving a flat look to the faces. I set the fill light two stops below the main light. The film used was Kodak VPS.

PSYCHOLOGY. Often it is best to have a parent in the room while a child is being photographed, but it can also be detrimental. I like to make that determination when I meet the child. Whatever my decision, I ask the parents to cooperate with me. One of the benefits of having a parent in the room is that they can watch for little things like a mis-placed strand of hair, or a wrinkle in the clothing. If a parent is watching the ses-sion, I ask him to move out of the child's sight. This keeps the child's concentra-tion on me, yet allows the parent to see the way I work with their child.

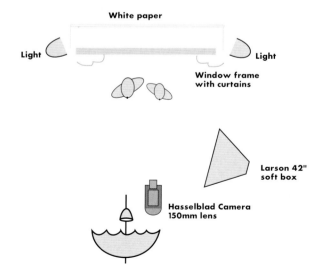

White paper

Light

Light

Window frame
with curtains

Larson 42"
soft box

Hasselblad Camera
150mm lens

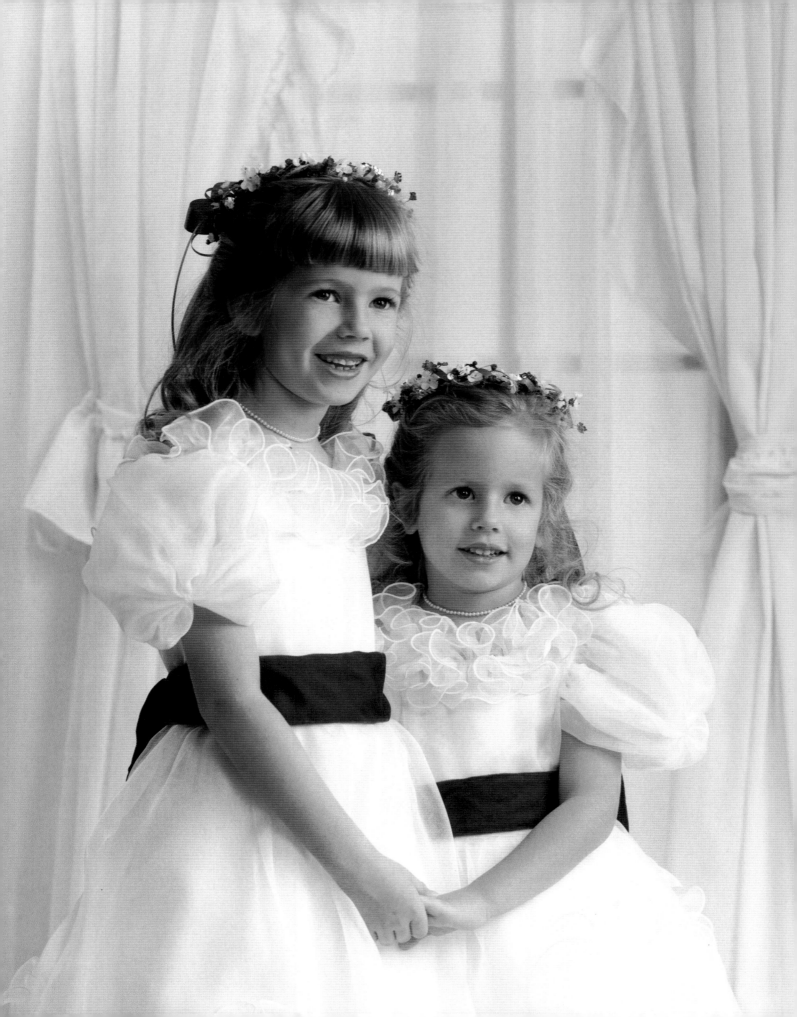

You Should Have Seen the Other Guy!

POSE. This is my youngest son. When he fell and bumped his eye on a table and got a black eye, I saw an opportunity to create a fun photograph. I set up this little boxing ring using yellow

I SET UP THIS LITTLE BOXING RING USING YELLOW CORDING PURCHASED AT A FABRIC STORE.

cording purchased at a fabric store. The cords were simply tied to light stands in front of the high-key background.

PROPS. I borrowed these boxing gloves from a friend and put my son in his red bathing suit. I did a series of photographs including several poses with his older brother. One was an "action" shot. I let the older boy put on one glove and hold it pressed against his brother's cheek like he was hitting him. The hardest part was keeping them from really socking each other.

BACKGROUND. Creating this background was really sim- ple. I used white paper and yellow ropes.

PHOTOGRAPHY. I mounted two small Photogenic Flash Master light heads from the ceiling and pointed the lights about halfway down on the background. The light then evenly illuminated the white paper background. The main light was the umbrella with the light shining through it.

The film used was Kodak VPS.

PSYCHOLOGY. When work- ing with your own children, an extra measure of patience is required, at least it is for me. I don't know why I expect my children to be more cooperative than my client's children. In fact, I guess I should expect less since they know me and know what they can get away with. I have decided to make the sessions fun and not just an opportunity to try out a new set or technique. My best advice is this: make a game out of the session. This particular session was both fun and easy to set up, a for- mula that always makes for great images.

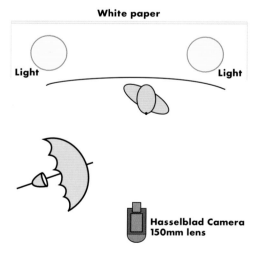

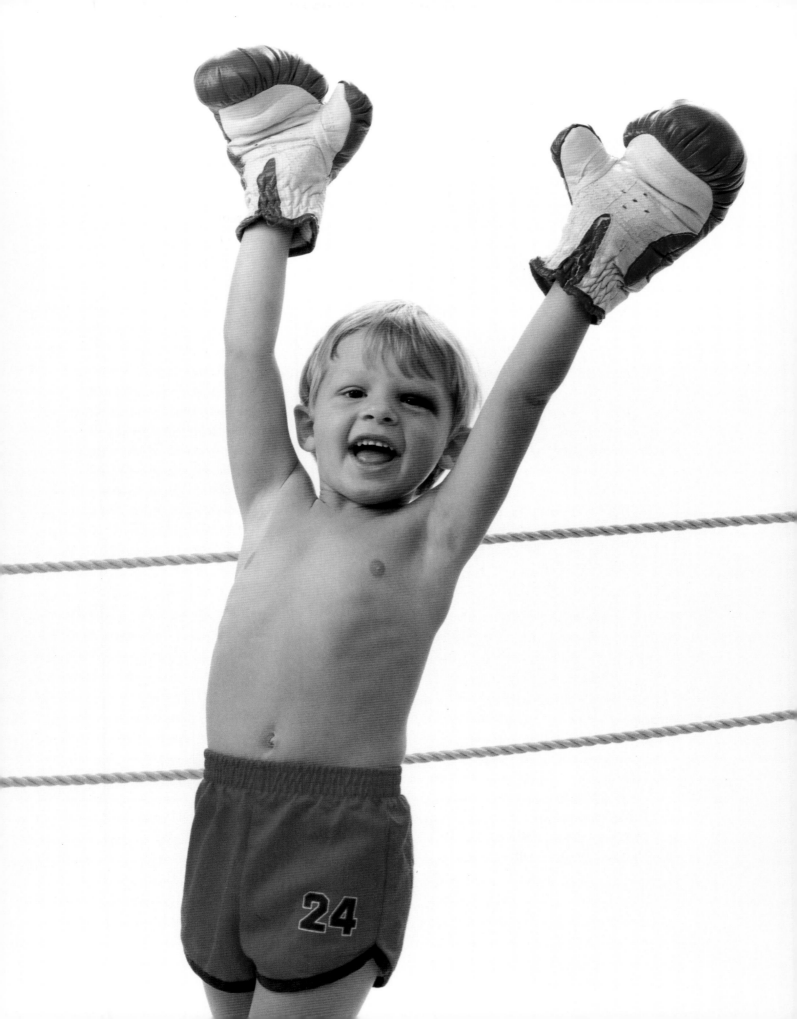

POSE. This little girl really got into washing her brother. One mistake I made was putting water in the bowl before I put the boy in. As you can see, I overestimated the amount of water to use and some water spilled out, ruining the white paper. Getting this image was worth the mess, though.

PROPS. All of the props were brought in by the mom. It's great when you do a cloth-

WHEN PHOTOGRAPHING MORE THAN ONE CHILD, I LIKE TO ADD A REFLECTOR TO THE SCENE.

ing conference to plan the session and the mother decides to do all of the work getting the props.

BACKGROUND. I got tired of buying white paper all of the time, so I painted the concrete floor of the camera room with white semigloss paint. I brought the paper down the wall until it came out about 18" onto the floor and taped it down with clear tape. I've never had to buy paper since—I just apply a light coat of paint every month or so.

PHOTOGRAPHY. This is another way to light a high-key photograph. I mounted

two small light heads on the ceiling and pointed the lights about halfway down on the background. The light bounced off the background and toward the foreground, thus adding light to the fore-

Washing the Baby

ground. The main light was an umbrella with light shining through it. When photographing more than one child, I like to add a reflector to the scene. In this case it was needed to light the face of the boy, who looked away from the main light. The film used was Kodak VPS.

PSYCHOLOGY. I tell parents, "If you feel your child will have a problem with shyness or they are afraid of strangers, please call the studio. We offer a free service called playtime that might help them prepare for the session. We ask that you bring your child to the studio a day or two before their session to meet and play with Mr. Box. This will create a bond of trust and results in better portraits. Please call for an appointment for playtime." We've photographed many children more successfully by putting out this extra little bit of effort.

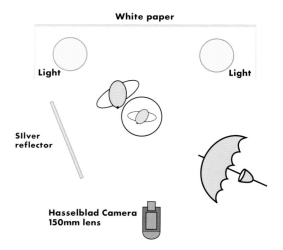

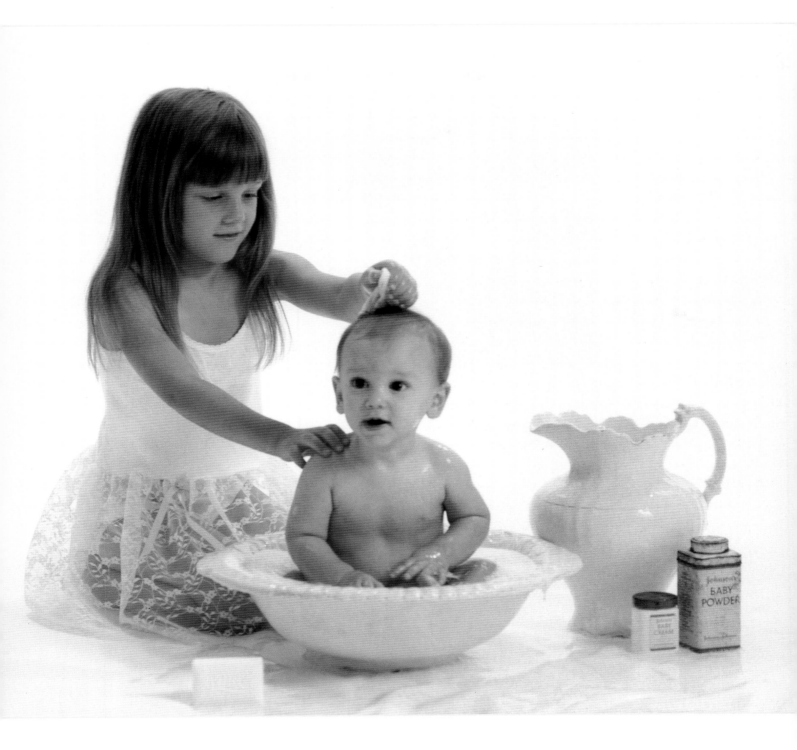

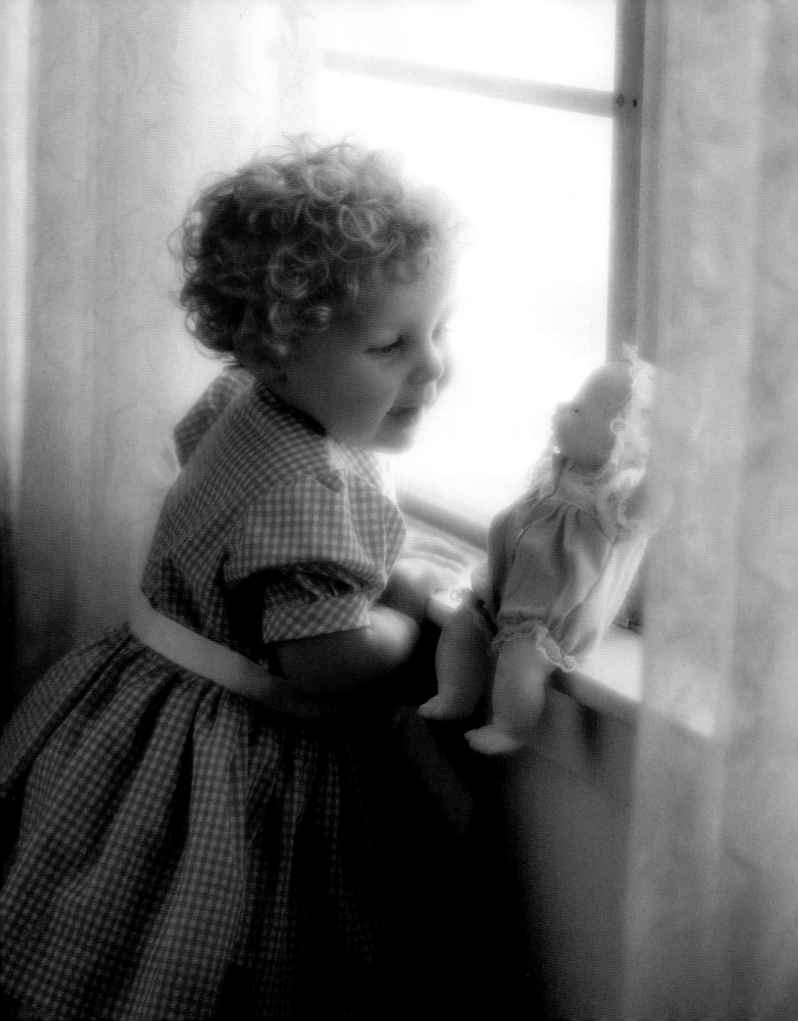

**Hasselblad Camera
120mm lens**

POSE. On this particular day, as I busily set up the camera, set the doll in the window, etc., this little client kept herself busy as well. I turned around and this is what I saw. This is why I love to work with children and this is why you always have to be ready. I focused and made the exposure. I felt the camera was a little too high, so I reset the tripod and moved the camera closer to the wall to keep some of the window out of the photograph and tried to recreate this moment. It was not to happen; she would never do it again. In the end it was okay, though, because I like this image just fine!

PROPS. This is a window in the sales room. I just opened

I LEARNED SOMETHING IMPORTANT ABOUT PHOTOGRAPHY FROM SHOOTING THIS IMAGE.

the curtains. I love windows and I love to work with window light.

PHOTOGRAPHY. I can't take much credit for this image. I was just lucky. I learned something important about photography from shooting this image. I was always under the impression that it was best to keep the light

Two in Blue

source out of the photograph—I always thought it would be too bright. This image illustrates that it can work quite nicely. This is just a machine print. This is not perfect posing for the face—it is not a profile or ⅔ view, but I don't care. It is cute and everyone loves it. I guess my clients don't care how portraits are "supposed" to be. The film used was Kodak VPH.

PSYCHOLOGY. I believe that a portrait should depict the way a child looks and feels at a certain age. Our portraits are usually ¾ or full length and feature a child relating to things other than the

camera. When I shoot children's portraits, I like to include a book, flower, or other small object that will help the camera capture the child's personality. To me, this is much nicer than a standard "smiling, looking at the camera with a blue painted background" portrait. While my preference is more challenging, the results are much more satisfying. I also believe that my clients will treasure this type of image longer than a more "traditional" one.

Heavenly Baby

POSE. This is a great pose for children four months old or younger. I placed the baby in the carriage near the right side of the window. I have

FOR A MORE PERSONAL LOOK, I ALWAYS ASK MOMS TO BRING THEIR OWN BLANKETS.

found if you hold small children's hands together for ten to fifteen seconds, the child will continue to hold them together a few seconds longer—just enough time to capture the image.

PROPS. This baby was posed in a large antique wicker carriage—a terrific prop that is well-suited to posing babies. This particular carriage has a large pillow in the bottom that brings the baby up high enough to be photographed, even from this low camera angle. For a more personal look, I always ask moms to bring their own blankets.

BACKGROUND. The background consisted of a white baby blanket draped over the carriage. This white on white look is great for young kids.

PHOTOGRAPHY. I had the baby's mom stand at the foot of the carriage so that she could capture the baby's attention. Placing the mom here, and using the pillow in the carriage caused the baby to look up. I lowered the camera angle a little, so that the viewer does not look down on the child. The win-

dow light wraps beautifully around the face. The exposure was $1/30$ second at f-5.6; the film was Kodak PPF.

PSYCHOLOGY. To get the baby's attention, I focused the camera and used a long cable release, then I moved my face to about 12" away from the baby and made small kissing sounds. I moved back once the child had seen and focused on my face. It usually takes two or three in-and-out movements to get the desired results. With some children, a soft clicking sound or even a gentle whistle works. Be prepared—many times you only get one or two chances before the trick does not work or the child's mood changes.

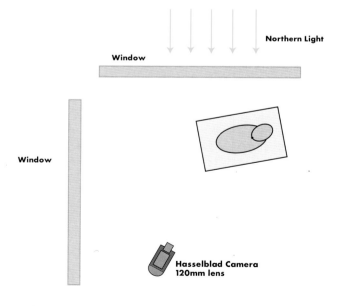

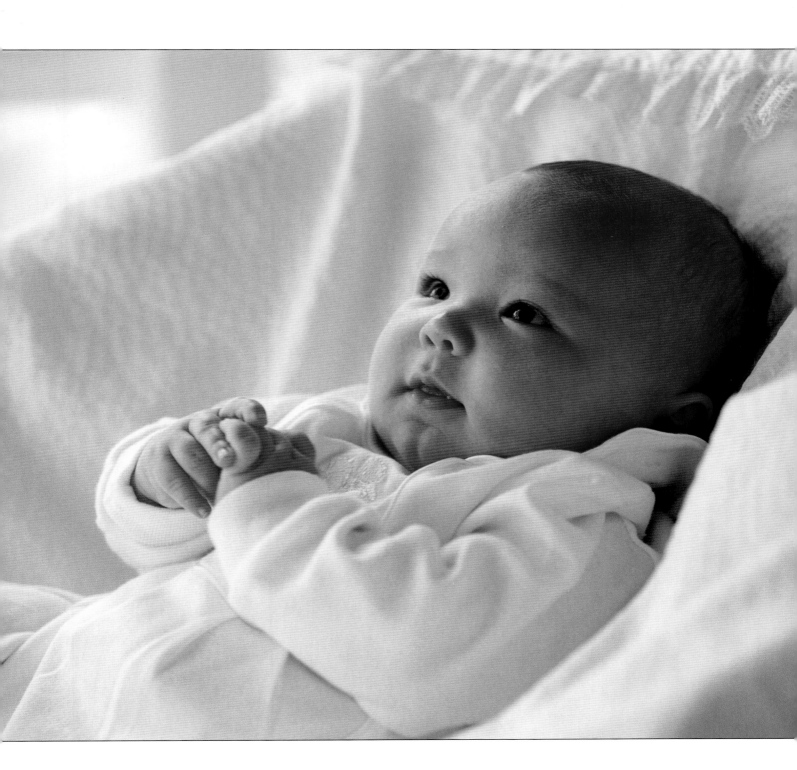

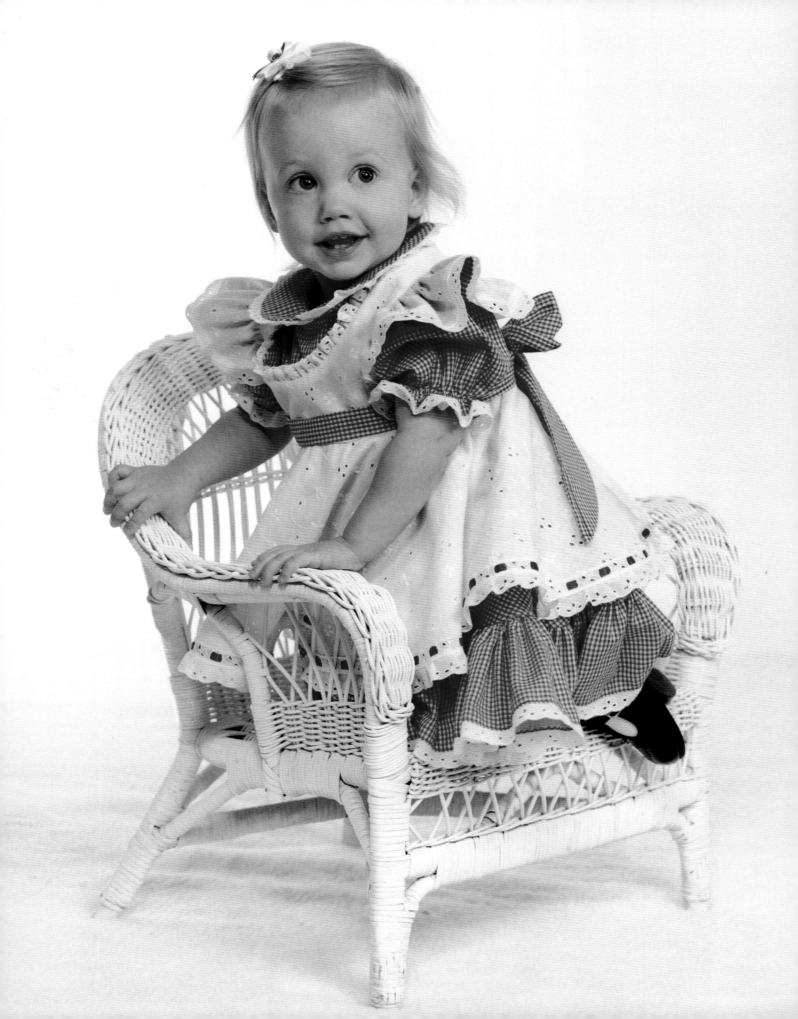

Sit Like This?

POSE. I placed a small pillow in the seat and asked the mom to place her daughter in the chair. Then, I had the mom call the girl's name. When she turned, I took the photograph.

THE LIGHT HITS THE PAPER AND BOUNCES TOWARD THE FLOOR WHERE THE SUBJECT IS STANDING.

PROP. I think half of the children in my area under the age of ten have been photographed in this chair. It is the greatest prop I have ever used. It works because it is small and the seat tips down in the back. I have photographed children as young as two months in it!

BACKGROUND. The background in this image is simply white paper. I brought the paper down to the floor at the back of the room and taped it down using clear packing tape. When I took this image, I used white fur on the floor. I don't use this anymore, because it doesn't go white enough. As I mentioned earlier, I've found that a concrete floor painted white works best. A commercial photographer once offered me some great advice: Buy your paint in a five gallon bucket. After you paint the floor with a roller, store the roller in the paint, in the bucket; this way, you won't need to clean the roller every time you use it.

PHOTOGRAPHY. I decided to include this image, an older photo, because it shows the wrong way to light high key. Notice the shadows and dark shading around the chair. I had pointed the background lights too far down, preventing the light from bouncing to the foreground.

The way I meter the high-key background is to have one stop of light more on the background than on the subject. Using an incident light meter, if the light on the subject is f-8, I adjust the background light to read f-11. I like the lights to be high—mounted on the ceiling, or on tall light stands. I have found good results if the lights are 2'–3' from the background, pointing down about halfway. The light hits the paper and bounces toward the floor where the subject is standing. This keeps the floor white around the subject. Even though the lighting here is not perfect, it is still a very nice image of a very sweet young lady.

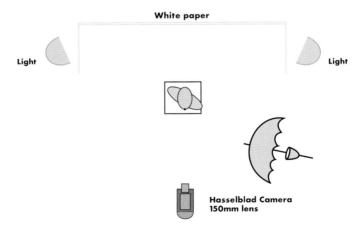

White paper

Light

Light

Hasselblad Camera
150mm lens

POSE. I photographed this boy in both a profile pose and this ⅔ face view. Everything stayed the same in both poses except the boy's face was turned a little to the left and the lights were shifted toward the camera. I gave him the pencil and just watched for the right moment.

PROPS. The antique desk, stool and thick books provided the feeling of an old-time schoolroom. There are two things I could have done to make this image even better: First, I could have straightened out the clothes, especially his shirt. The second change I could have made was in the selection of background color. The rule of thumb is that light-colored clothing usually photographs best on a light-colored background, and dark colors on a dark background. However, it is still a fun image.

BACKGROUND. The background was a hand-painted wall in the studio. It has browns, tans, and a little blue.

PHOTOGRAPHY. For this portrait, I used a low camera

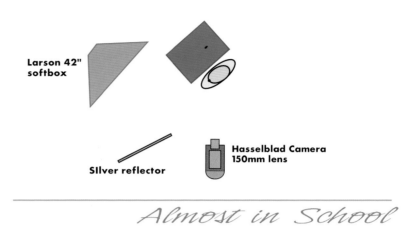

Larson 42" softbox

Silver reflector

Hasselblad Camera 150mm lens

Almost in School

angle and placed the subject in the lower right-hand corner of the photograph. I like to keep children small in the photograph. If you look closely at the little boy's eyes, you'll see that the catchlights are in the ten o'clock position. This indicates proper placement of the studio lights. The film used was Kodak VPS.

PSYCHOLOGY. A good portrait of a child can never be rushed. I like to reserve plenty of time for a child's portrait session. Sometimes I spend up to twenty minutes just greeting a child and building trust before beginning the session. I recommend that parents not schedule the session near other appointments.

I RECOMMEND THAT PARENTS NOT SCHEDULE THE SESSION NEAR OTHER APPOINTMENTS.

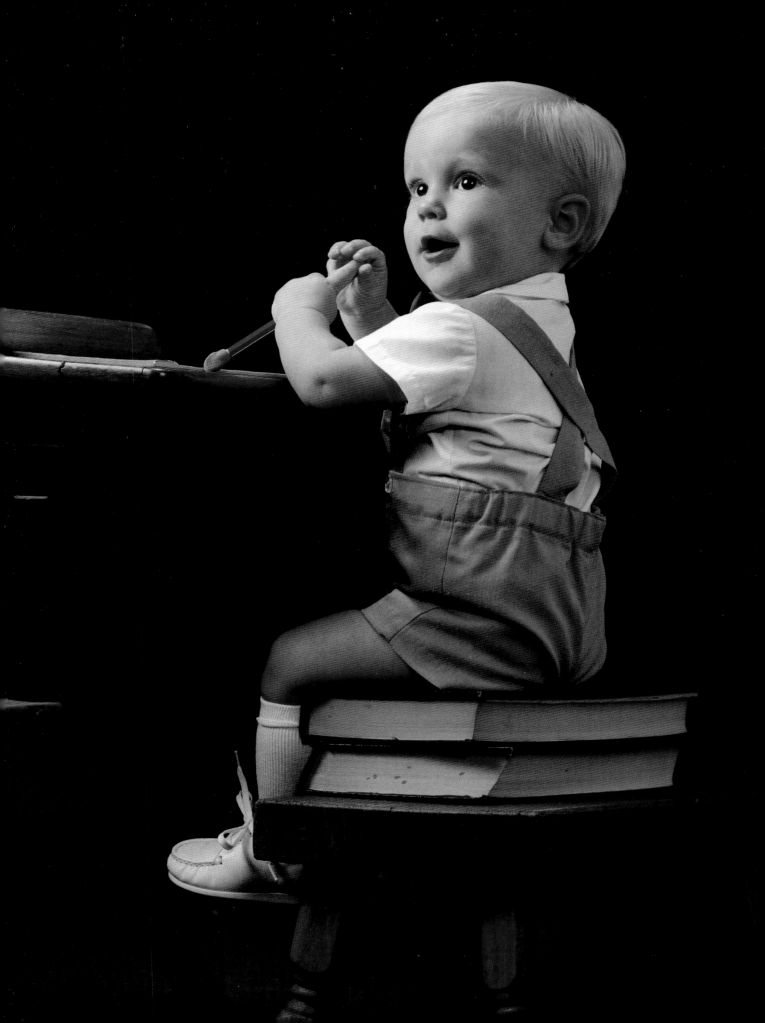

POSE. Posing brothers together this closely can sometimes be challenging. I usually start with them further apart and slowly, as the session proceeds, bring them together. The slight tilt of their heads gives a feeling of caring and closeness. These little guys may not care for each other right now, but someday they will.

THESE LITTLE GUYS MAY NOT CARE FOR EACH OTHER RIGHT NOW, BUT SOMEDAY THEY WILL.

PROPS. Jean jackets with no shirts make for a simple photograph. This focuses all of the attention on their faces.

BACKGROUND. The background is a gray blotchy muslin background from Les Brant (see the resources section in the back of this book). I placed it about eight feet behind the boys to throw it out of focus.

PHOTOGRAPHY. The lighting used in this image is a modified butterfly lighting. Butterfly lighting is achieved by placing the light over the camera, and in the area between the camera and the subject. The lights used were Photogenic Flash Masters, which are reasonably priced and very versatile. I've used

Tough Guys

them for almost fifteen years and have had almost no problems. The Larson 42" soft box was placed above and to the left of the camera. The reflector is placed low and to the right of the camera; I tilted it back and forth to visually fill in the shadow area. A hair light, placed high and to the right, and a background light separates the subjects from the background. A Coken 083 soft

focus filter was held in front of the lens. Exposure was $1/60$ second at f-8; the film used was Kodak T-Max 400, rated at 200.

PSYCHOLOGY. Both of these brothers were in a good mood for this session. However, if siblings don't want to cooperate, I quickly get their minds off the photography session by talking about sports, fishing, school—or anything that will take their minds off what we are doing.

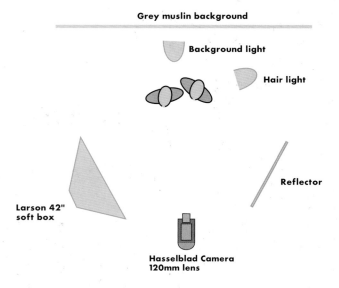

Grey muslin background
Background light
Hair light
Larson 42" soft box
Reflector
Hasselblad Camera 120mm lens

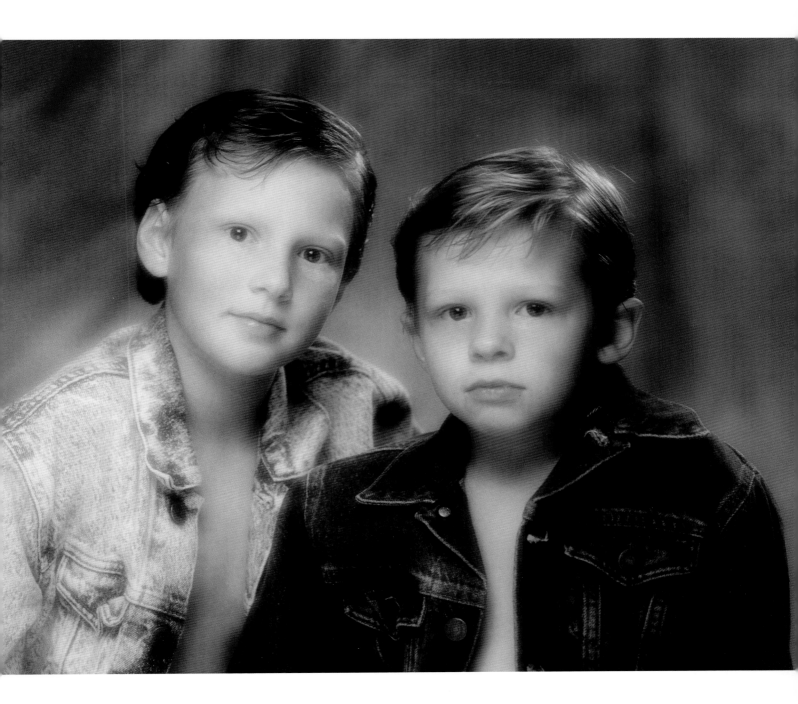

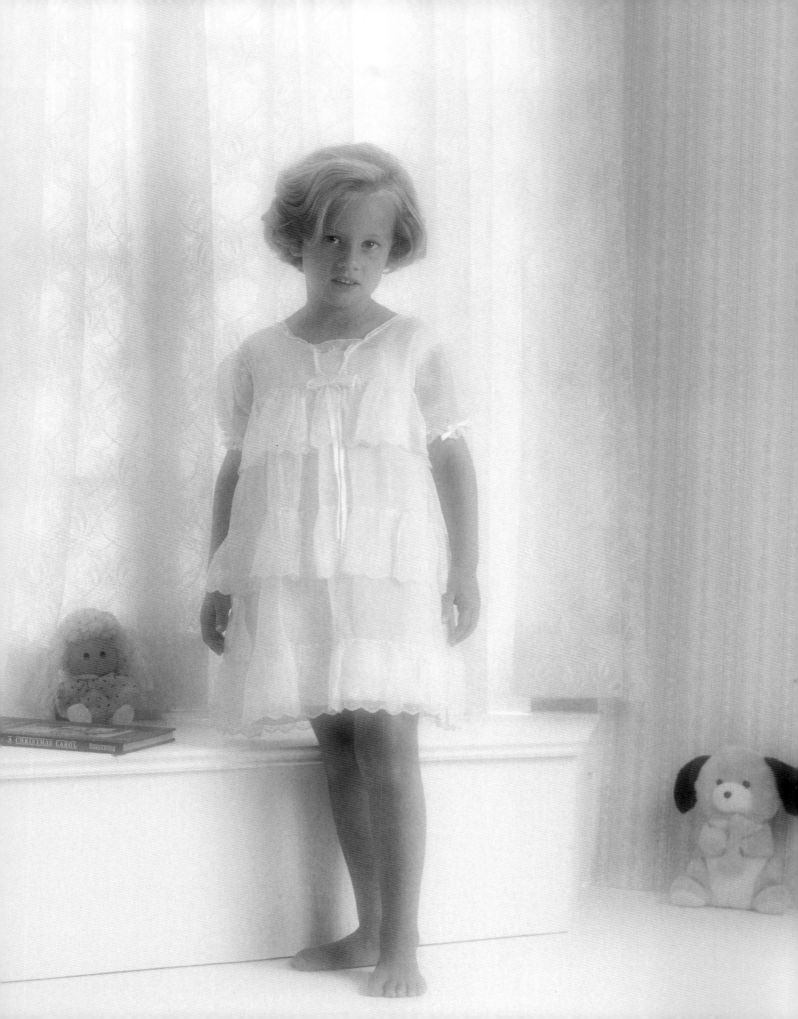

Simple in White

POSE. Several things can be learned from this simple portrait. The posing is very basic. The child's weight was placed on her back foot, her shoulders were turned away from the light, and her face was turned back toward the light. It is classic feminine posing, with the back shoulder slightly dropped and the forward foot pointed toward the camera.

PROP. Adding the bear, doll, and book creates the look of a girl's room. I kept the light off of these props to prevent them from becoming too prominent. The white dress and bare feet complete this simple look.

BACKGROUND. The white room seen here appears in other images in this book. To personalize it, I propped up paneling against the fake window and added the window seat. (You can also see the painted floor that I mentioned earlier!)

PHOTOGRAPHY. Notice the placement of the umbrella and reflector. I usually place my light source in just this position, with the back side of the apparatus slightly in front of and feathered past the subject. This way the main intensity of the light goes past the person and hits the reflector. I place the reflector on the other side of the subject in the same position. Carefully turn the reflector until you see that it gives you the maximum light return.

CLOTHING. A book of "proper" clothing samples is an indispensible tool for any photographer. Proper clothing selection is critical to the final quality of the image and a point where clients often need guidance. It is best to ask a client to bring several outfits ranging from casual to formal. Ask your clients to bring several items that they would like to have included in the portrait so that you can tell them which of the items will photograph best.

On page 118, I have included a sample of a handout that I give to all of my portrait clients. Clothing selection, among other things, are covered in this handout.

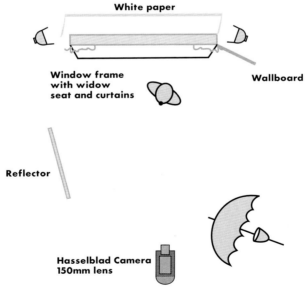

White paper

Window frame
with widow
seat and curtains

Wallboard

Reflector

Hasselblad Camera
150mm lens

light falloff. This gives you more control by allowing you to direct light to one area and still get the soft quality of a large source.

Relationships

POSE AND PROP. This style of photography has been popularized by two colleagues, Jack Holowitz and Tim Walden. I love it! Basically, the subjects are dressed in black and photographed against a black backdrop. This brings your attention to their faces and hands. Tim and Beverly Walden coined the phrase "relationship photography" to describe this style that shows the closeness between the subjects. Notice how the young lady is touching and being held by her mom. The photograph is about the relationship between them.

BACKGROUND. The backdrop is black canvas. You can't see it here, but it has lighter painted highlights.

CLOTHING. The clothing is from a selection of garments I keep on hand for this style of photography. I personally prefer black clothing with collars and sleeves.

PHOTOGRAPHY. I used a large 4' x 6' Larson soft box for this portrait. This is a great piece of equipment because it produces a very soft quality of light. Another feature of this particular large soft box is that it is not as thick as others (from back to front), making it more versatile—especially in smaller camera rooms. It also has a bit of a hot spot with nice

PSYCHOLOGY. One of the most important benefits of photographing kids (especially small ones) with their parents is that they feel comfortable. You don't have to pull them away from their mom and sit them on a chair all by themselves. Instead, they are cuddled and comforted by someone who

THEY ARE COMFORTED BY SOMEONE WHO MAKES THEM FEEL SECURE.

makes them feel secure. This makes getting different expressions (especially quiet looks) much easier.

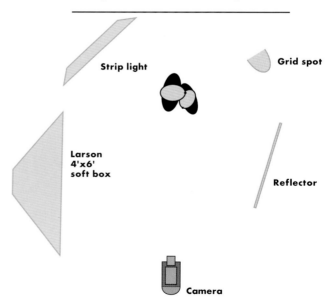

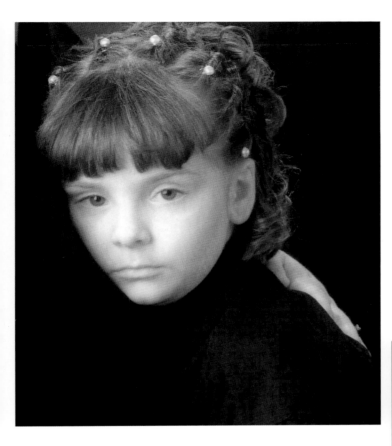

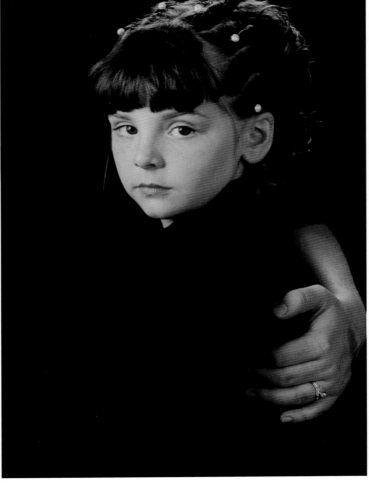

SECTION

2

OUTDOOR AND LOCATION IMAGES

Father and Son Fishing

POSE. There wasn't much posing going on here! I just let the dad and his son fish. I have presented two different versions of this image. One (small photo) is vertically

MATCHING OUTFITS AND SIMPLE BUT EFFECTIVE.

composed, the other is horizontally composed (large photo). The horizontal image is also soft focus. You can decide which one you enjoy most.

PROPS. Matching outfits and hats make this pose simple but effective. Try to imagine this image with distracting clothing.

PSYCHOLOGY. You really don't have to do much directing with this type of image. Most dads enjoy spending this kind of quality time with their sons.

PHOTOGRAPHY. I like the horizontal composition best. In a vertical composition,

there is a lot of space above and below the subjects. I've always been told if a part of the image is not working for you, it is working against you. In this example, you

HATS MAKE THIS POSE

can see that the horizontal composition better directs your eye to the subjects. I

really like the interaction between the subjects in this photograph. The soft focus is created with a Coken 083 filter. My only problem with this filter is that it tends to flare white clothing; it did just that in this image but, thankfully, it was not too objectionable. The film used was Kodak PPF, exposed for $\frac{1}{60}$ second at f-5.6.

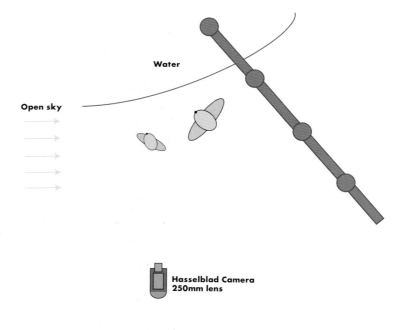

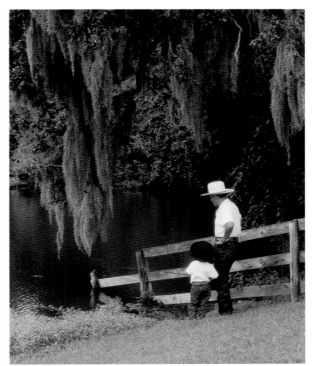

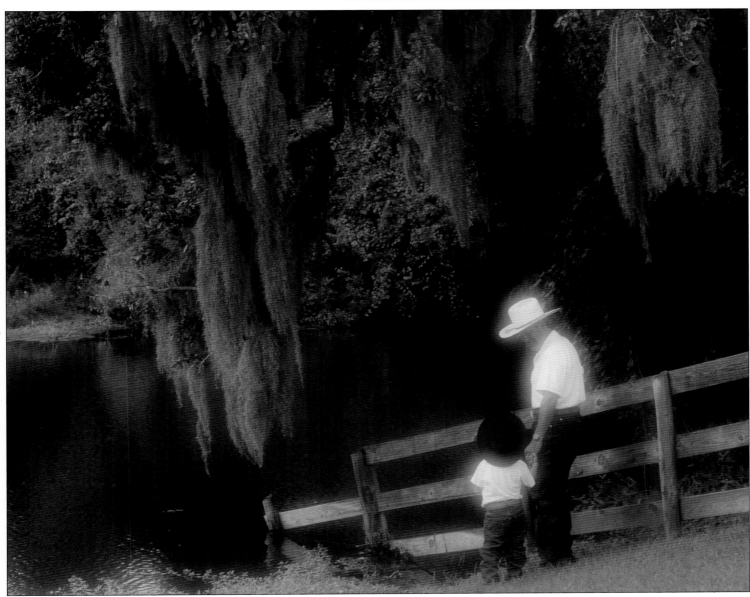

Peter Rabbit's Garden

POSE. What could be simpler? I sat the small child down and leaned him against an overturned washtub. Notice the bare feet. Little

LITTLE CHILDREN'S TOES ARE ALWAYS CUTE IN A PHOTOGRAPH.

children's toes are always cute in a photograph. What do you do with little hands? Give them something to hold—but keep mom close because everything goes in the mouth.

PROPS. The cute little hat is really the only prop in this image. Everything else is part of the background. Thank goodness some children smile easily—this little boy does and does it well. I was glad, because the mom wanted to show off both of those teeth!

BACKGROUND. Our herb garden is built next to a storage building. Included in the set are the washtub, an old watering can, some real herbs, some silk sunflowers, an old washboard, a couple of clay pots and the sign. The back wall is old barn board.

PHOTOGRAPHY. When I took this shot, I noticed that there was too much light coming from the top—looking at the little boy's arms you can see it. I realized that installing a tin roof would block some of this light, and installed one that comes out about eight feet from the back wall.

With the tin roof in place, it was necessary to re-meter. Incident meters offer

Building

two options: metering with a half-round dome or a flat disk. I prefer to use the flat disk, as it gives me more accurate exposures. This is a great example of using the flat disk. Because of the strong top light, the dome would have also read the light from above, giving the wrong reading. The result would have been underexposure. It is very important to test your equipment, film, and metering techniques. Consistency is very important. When I use the flat disk, I always point it straight at the camera to ensure consistent results. Exposure was $1/60$ second at f-5.6; the film used was Kodak PPF.

PSYCHOLOGY. Not much psychology was needed with this happy little fellow. A simple game of patty-cake prompted this great expression and pose.

Western light

**Hasselblad Camera
250mm lens**

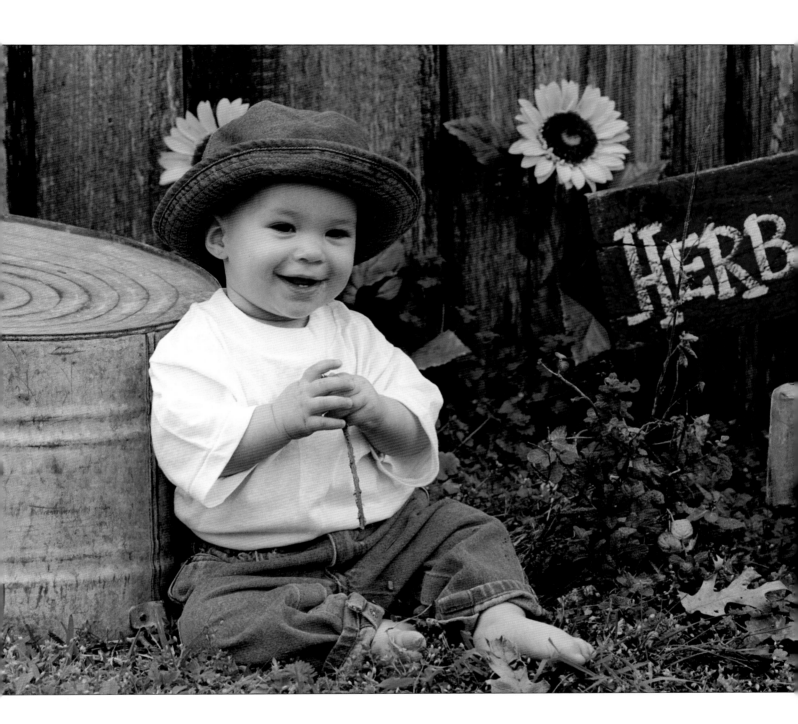

POSE. This was one of the first Heirloom Portraits I did. This is a very natural pose for a small child and her mom. I turned the mom toward the window light and sat the small girl on the mom's lap.

PROPS. This image was shot on location at the client's house. I believe that creating images on a client's own property adds a special, more personal touch to the photographs. The dresses and the furniture are theirs.

VARIATIONS. Here you can see two presentations of the same basic image. The first is the color image (top). The second is a sepia toned print that is mounted on brown paper (bottom). The paper was hand-torn and mounted with spray adhesive on an off-white art board. I wanted to create the illusion of a print torn from a scrapbook, then mounted and framed.

PHOTOGRAPHY. This photograph was taken in the breakfast room at the client's house. There were windows on two sides of the room. The window to the right of the camera provides the illumination for the image. I

Mother and Daughter

brought a silver reflector in from the left side. When I first arrived, the sun was shining in on the area where the furniture is sitting. I put a translucent scrim outside

HERE YOU CAN SEE TWO PRESENTATIONS OF THE SAME BASIC IMAGE.

up against the window to soften the sunlight. A few minutes later the sun moved and I no longer needed the scrim. The film used was Kodak TXP rated at 200.

HEIRLOOM PORTRAITS. Heirloom Portraits are old-fashioned, black and white images hand-printed on Kodak Ektachrome G fiber-base paper. I like to use fiber-base paper for its authenticity and archival quality. Some of the images, as in the example shown here, are hand-tinted with pastel chalks, then coated with photographic lacquer.

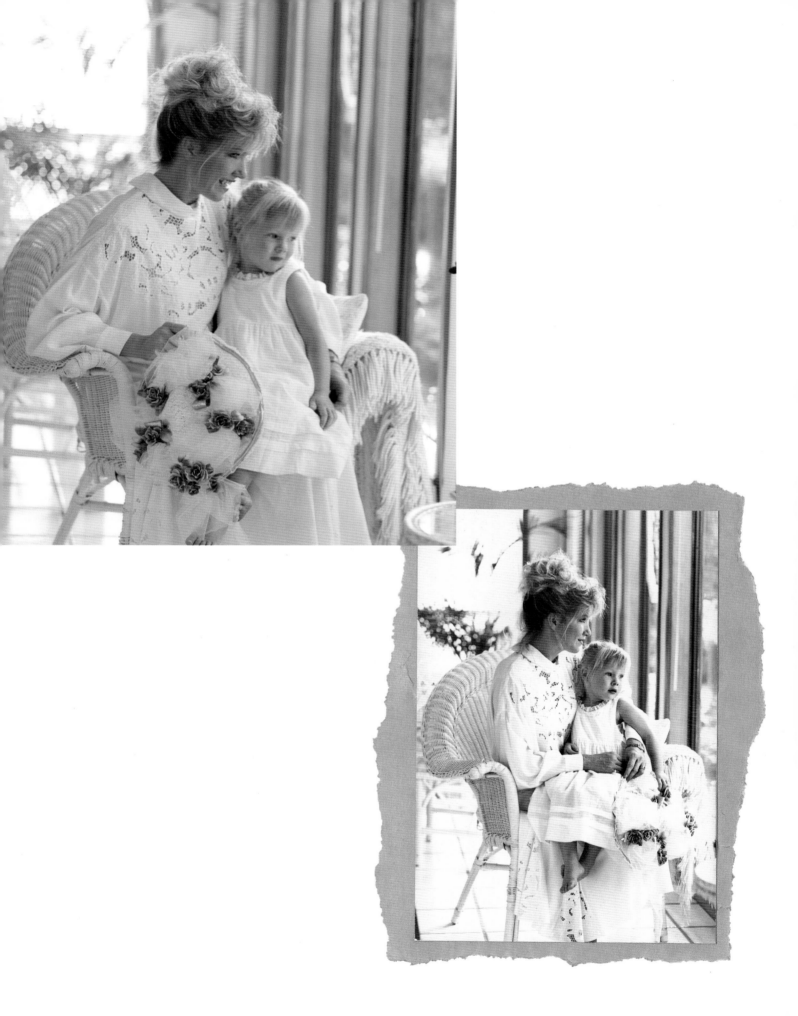

I chose a triangular composition for this family. I started by posing the father sitting on the log. I could also have photographed dad alone in this same pose. Next, I added mom. This could also have been a great image of just the two of them. Finally, I added the daughter leaning on dad's shoulder. This contributed a sense of strength and tenderness to the image.

PROP. The driftwood log on the beach makes a great prop. It gave the family something to sit on and around and added a diagonal compositional element to the image. Coming into the frame from the lower right corner, the log leads your eye to the family. Also,

sun provides direction, but does not overpower the photograph. I used a 250mm lens to throw the background somewhat out of focus. The photography is really quite simple. I just used a camera, tripod and a light meter. The film was the new Kodak Portra VC. This film has great latitude and color tonality.

BACKGROUND. I chose an area of the beach that provided a background with

PSYCHOLOGY. Be ready! Many times when photographing children you only get one or two chances. Children sometimes get bored, especially if you have to wait very long. Always set up and prefocus the camera, because opportunities for a great shot may pass quickly!

NOTICE HOW NICELY THE CLOTHING MATCHES THE OVERALL COLORS OF THE PHOTOGRAPH.

notice how nicely the clothing matches the overall colors of the photograph.

PHOTOGRAPHY. When photographing at the beach it is often difficult to find directional light—especially after the sun goes down. I chose to wait until the sun was almost down to make the exposure. The late afternoon

minimal distractions. Notice how the shoreline acts as a leading line to bring your eye right to the subjects. The muted tones of the beach grass go great with the colors of the clothing.

Seashore Family

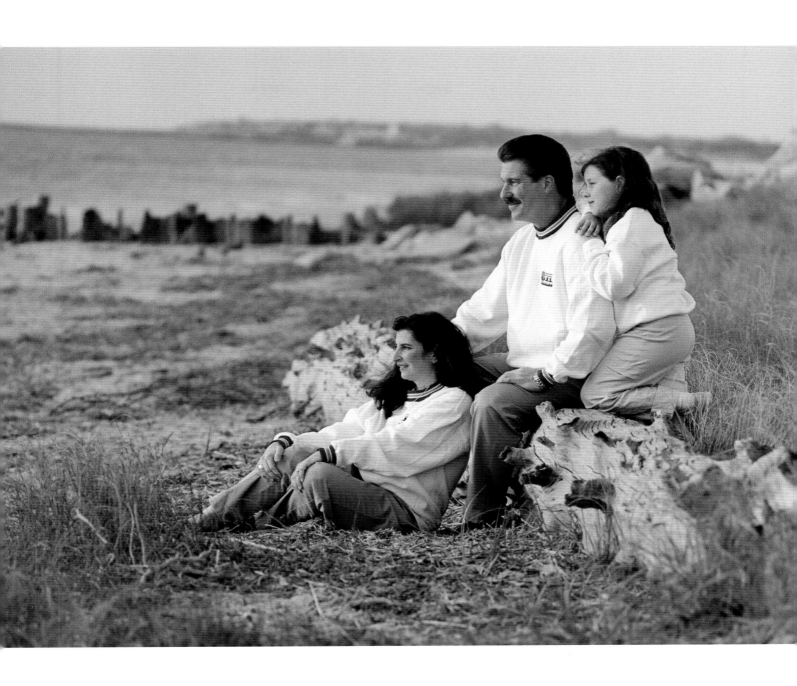

POSE. One of my favorite sitting poses for children involves tucking one of their legs under the other leg. In this pose, I turned the boy's shoulders slightly away from the window, then turned his face back toward the window a bit. Notice that the boy's eyes are centered in the eye sockets. Typically, when people look away from the camera, their eyes are fixed on a spot that is not in sync with the direction of the face; this leaves too much white of the eye showing. An important rule in posing is "The eyes follow the nose." To achieve this, give the client something to look at, then turn his or her face to center the eyes in their sockets.

PROPS. This antique camera complemented the little boy's hat, bow tie, and sweater. When selecting props, it is important to ensure that they do not dominate the photograph.

BACKGROUND. This is a window seat built into the north wall of the camera room. It is painted egg-shell white. Although this image was shot by a window in the studio, the look would also

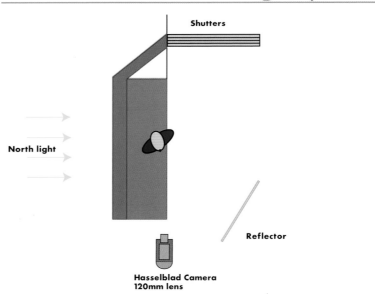

Littlest Photographer

Shutters

North light

Reflector

Hasselblad Camera
120mm lens

work on location. Behind the young man is a pair of shutters. They are 18" x 72" each. They are hinged together and are movable. They are egg-shell white on one side, and pure white on the other. This extends the usability of the set.

PHOTOGRAPHY. I used the 120mm lens because of its shorter focal length. The room is not very wide. To determine proper exposure, I placed the meter near the boy's face, pointed directly at the camera. Exposure was $\frac{1}{60}$ second at f-5.6; the film used was Kodak VPS.

IT IS IMPORTANT TO ENSURE THAT PROPS DO NOT DOMINATE THE PHOTOGRAPH.

PSYCHOLOGY. Children's demeanors will generally reflect your own. For a soft, quiet mood, you should move slowly, act calmly, and speak in soft, quiet tones. Of course, the opposite is also true: If you want a quiet child to perk up and show you big smiles, then get a little louder, smile, and laugh a lot. Playing silly games with the child is sure to elevate his or her mood and excitement.

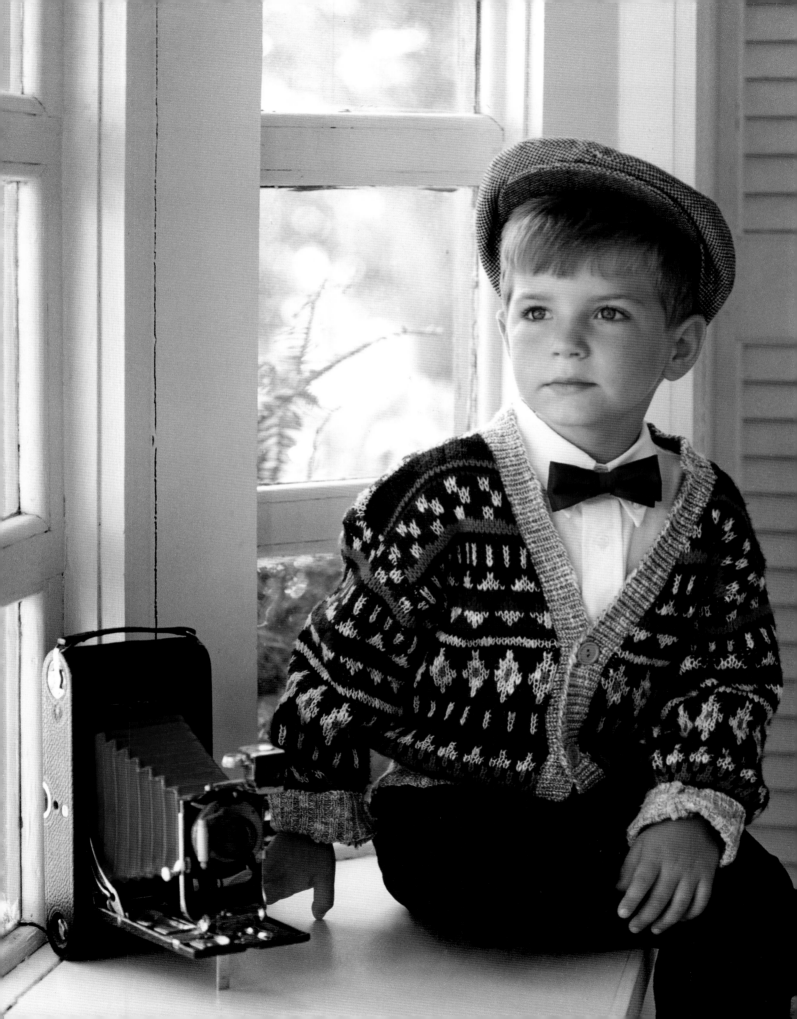

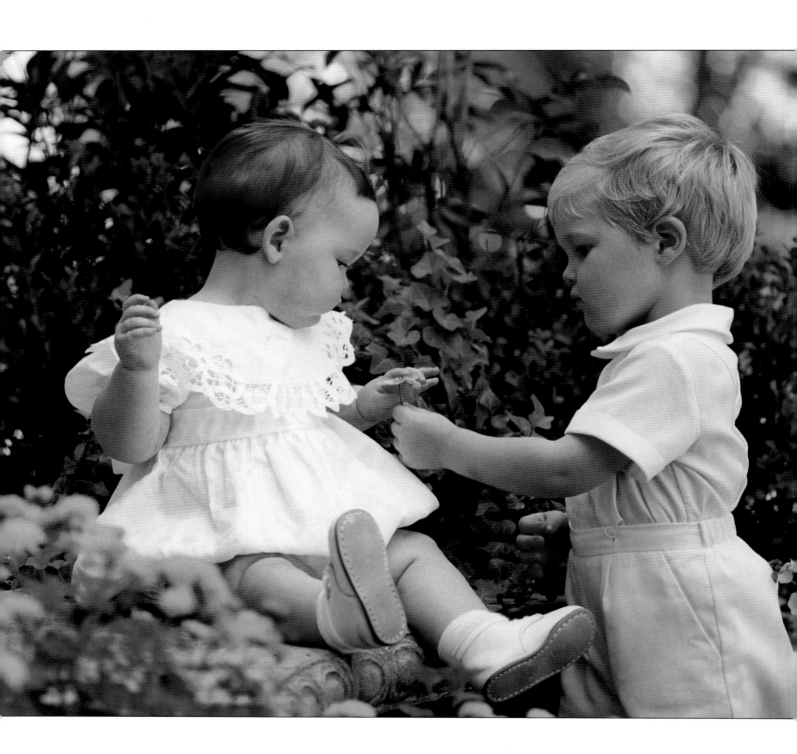

POSE. I love the innocence of these two children sharing the joy of playing with the flower. Their mother asked the boy to show the flower to his sister. You have to be ready and react fast with small children, especially with two small children. This is where the extra speed of the PPF film comes in handy.

PROPS. The mom did a great job of picking out the outfits for this session. The boy's white shorts set is great for this outdoor scene.

BACKGROUND. The background was set up using five-gallon potted plants. The concrete garden bench is sitting on the porch.

PHOTOGRAPHY. Using a 250mm lens allows me to be reasonably far away from the children and allows me to remove myself from their consciousness. As you can tell by the background, this was not taken at prime time for out-

THE BACKGROUND WAS SET UP USING FIVE-GALLON POTTED PLANTS.

door portraits. Because I have to take photographs at almost every time of the day, I built this posing area. The area is shaded in the after-

Building

Eastern light

Flowering
plants

Hasselblad Camera
250mm lens

Sharing

noon by the building. The plants in the shade block most of the bright areas in the background. Exposure was $\frac{1}{60}$ second at f-5.6; the film used was Kodak PPF.

PSYCHOLOGY. When photographing shy children, I am often completely quiet and let a parent work with and direct his or her children. In choosing to use a long lens, I can almost "hide" behind the camera and, by not saying anything, the children will forget I am there and begin to act normally. Listen

to parents about the mood and disposition of their children. As an unfamiliar man, I find children are sometimes afraid of me. This is where women and parents have an advantage.

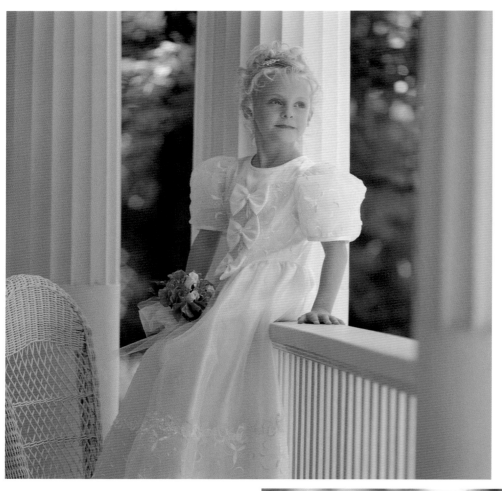

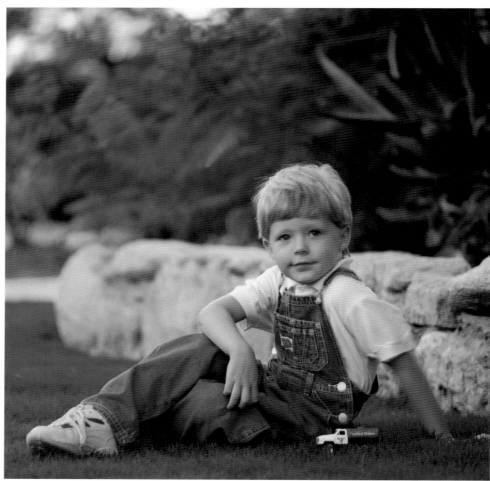

LIGHTING. Here are two images created using only natural light. When creating a natural light portrait, your main concern should be to find a good clean source of

YOUR MAIN CONCERN SHOULD BE TO FIND A GOOD CLEAN SOURCE OF LIGHT.

light. It is also important that the light have direction. Without this directional quality, the subject's face will lack the soft shadows that reveal its shape to viewer's of the portrait. For the most flattering effect, the light should come from the side of the subject. If the angle of the light is too high, it will create unflattering shadows under the eyes (this effect is often called "raccoon eyes").

In the top photograph, a porch was used to modify the light. With the roof blocking all of the light from above and the building blocking the light from camera left, the remaining light has a nice directional quality. As shown in the bottom portrait, trees and plants can be used to modify light in the same way. Shooting near sunrise or sunset, when the sun is naturally at a low angle, can also help you to achieve the same effect in open areas.

POSING. In both of these images, I used seated poses to photograph the two adorable children. In the top photo, the girl is sitting on the railing of the porch. In addition to being a natural pose, it allows her special dress to be seen clearly. As you can see in the bottom photograph, the ground is a great place to pose people—especially children. I think kids feel especially comfortable sitting on the grass. In both of these images I used the 250mm lens on the Hasselblad and Kodak 400 speed Portra film.

Natural Light

POSE. This little boy is posed on a bridge. See how cute hats can be? As you probably can tell, he was about to take the hat off when I captured

PHOTOGRAPHING CHILDREN CAN BE FUN IF YOU KNOW THE SECRETS.

the image, but it looks like he has just put it on.

PROPS. The hat and fishing poles are popular props for small boys visiting my studio. So are overalls. I have a collection of these in several sizes. Every once in a while, no matter how much talking you do about clothing, moms will bring an outfit with a huge cartoon character on the front. I take a few images in that outfit, then tell mom about this great idea I have with a fishing pole and hat. I ask her if she happens to have a pair of overalls with her. No? That's okay, I just happen to have a pair that will fit. Whew, I dodged that one!

PHOTOGRAPHY. I used available light—nothing special here. Just straightforward metering and exposure. I do like the little scowl on this boy's face. Kids don't always have to smile. The film used was Kodak VPH; exposure was $\frac{1}{60}$ second at f-8.

PSYCHOLOGY. Photographing children can be fun if you know the secrets. It can also be demanding. I will admit that it does help to be a child at heart. You should enjoy playing games and pretending. You should enjoy sitting on the floor and crawling on your hands and knees. You should also enjoy being silly and laughing a lot. If you don't enjoy all of these things, that's okay, but get someone to work with you that does. Then you can hide behind the camera, be quiet, and take the photographs.

North light

Hasselblad Camera 250mm lens

Wooden bridge

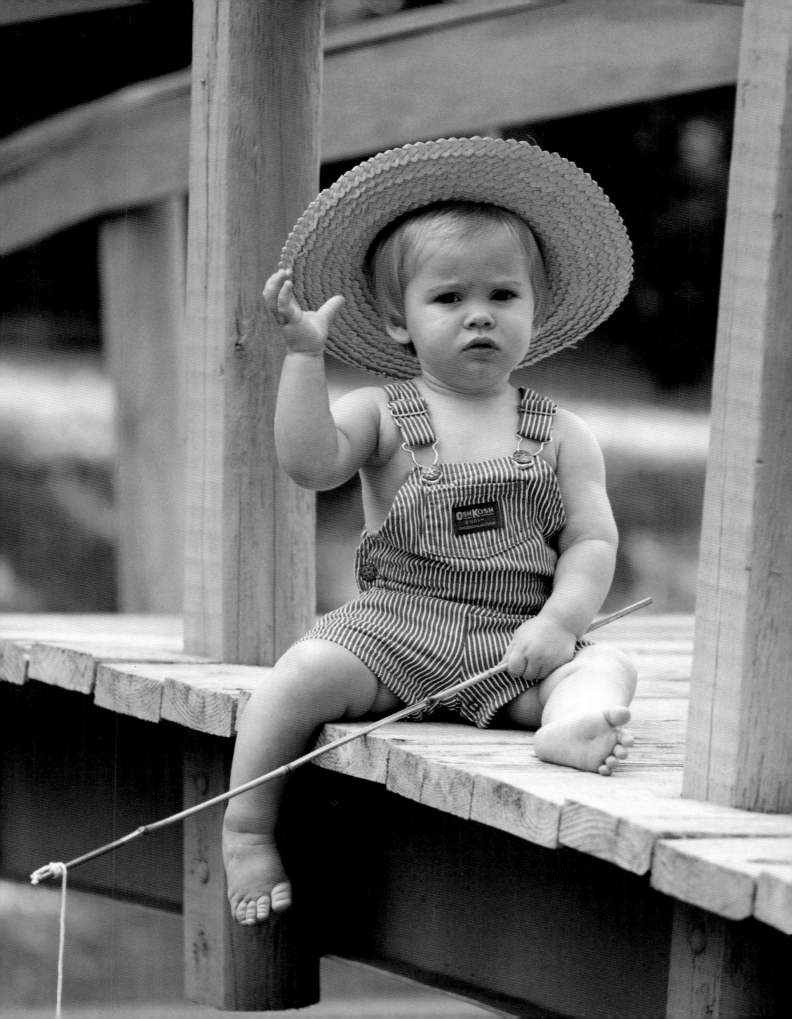

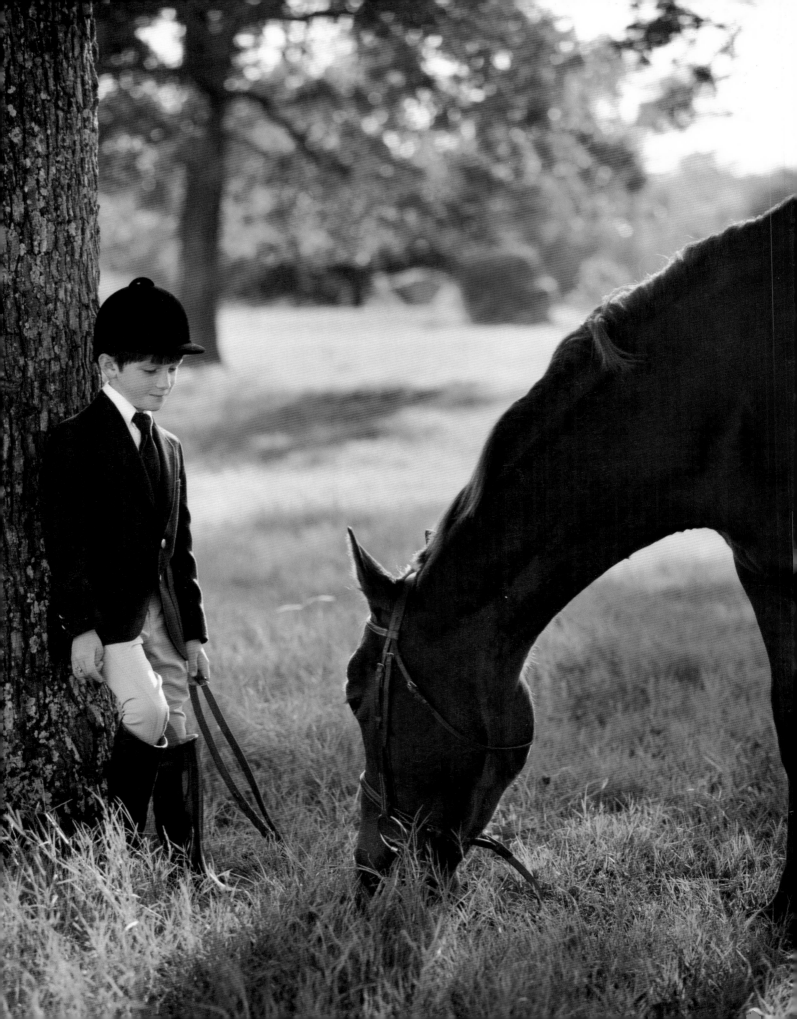

POSE. I believe that little things make a big difference. Here, the boy's leg is bent, and his face is turned so that you can see both eyes, but

I THINK THIS LITTLE OUTFIT MAKES THE IMAGE SEEM MORE FORMAL.

the far eye is contained inside the line of the face. The same thing applies to the nose. The end of the nose does not protrude past the edge of the boy's face. I especially like the gentle way he is holding the reins.

PROPS. The riding outfit and the horse are the props. I think this little outfit makes the image seem more formal.

PHOTOGRAPHY. If I could re-shoot this image, I would use a longer lens, like the 250mm. Notice the bright sky in the upper right-hand corner of the photograph. It is a little distracting. You can crop it out by taking off the top quarter of the image. However, I like the space

above the boy, it showcases the boy's small stature and gives the image scale, especially compared with the big animal. Using a 250mm lens, which has a smaller angle of view, would have effectively kept the sky out of the photograph. The hardest part in creating this image was finding just the right spot that

would allow a little soft, direct sunlight hitting the boy, but not causing the foreground to wash out. The film used was Kodak PPF; the exposure was $\frac{1}{60}$ second at f-5.6.

PSYCHOLOGY. When I want a soft expression, I speak in soft tones. In this case, doing so prompted the boy to relax, speak softly, and even calmed the animal.

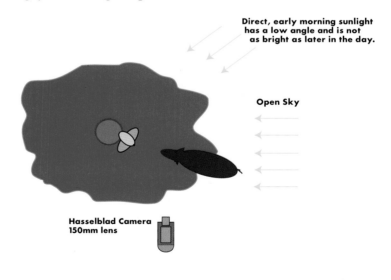

Direct, early morning sunlight has a low angle and is not as bright as later in the day.

Open Sky

Hasselblad Camera 150mm lens

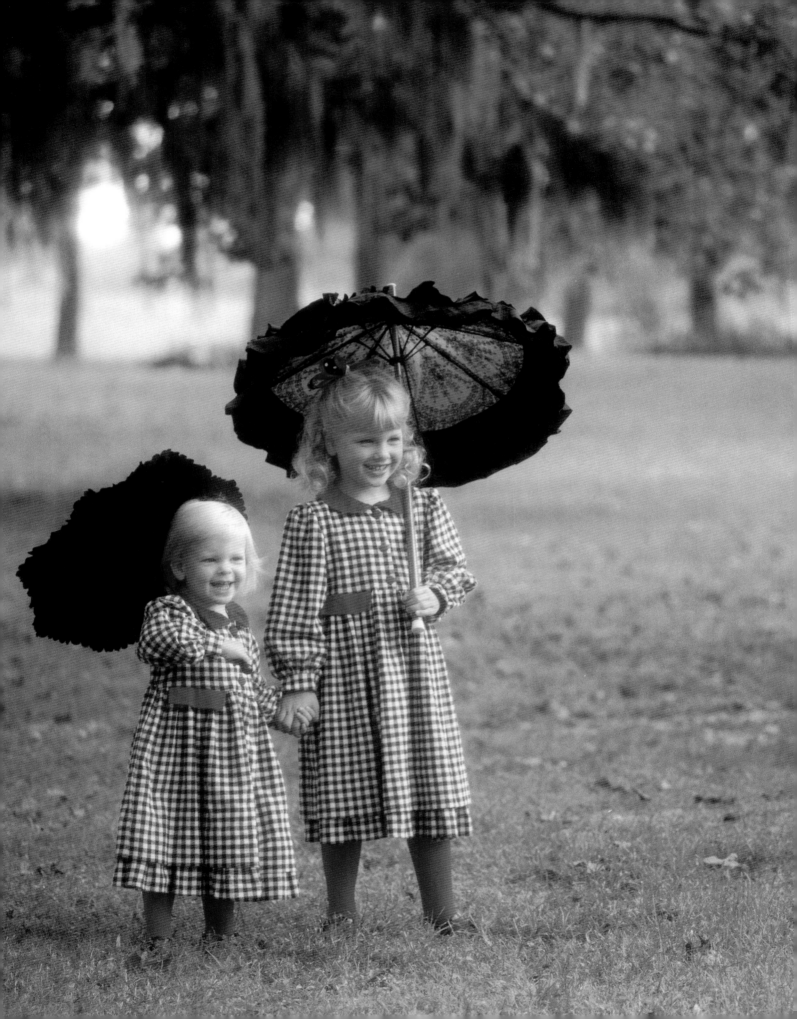

POSE. I had the girls put their weight on their inside feet (the feet closest to each other) and brought their

THE YOUNGER THE CHILD, THE HARDER IT IS FOR THEM TO HOLD THIS POSE FOR LONG.

outside feet out slightly, forming a modified C-pose. The younger the child, the harder it is for them to hold this pose for long. This is especially true when they have to hold hands with each other and hold an umbrella at the same time.

PROPS. I love when children are dressed alike. This way, the clothes don't take attention away from the girls. The mom had these umbrellas. They are a little dark for my tastes, but I felt they matched the dresses and added a nice touch.

BACKGROUND. This was photographed at Grandpa's house. The place was important, so I chose the 150mm lens to let more of the detail in the trees and the moss show. If I had chosen the 250mm, the background would have been more out of focus.

PHOTOGRAPHY. Notice the direction of light on the girls' faces. You must look for open sky for a light source. This was taken mid-morning; lucky for me there was good cloud cover. This kept the sun from making hot spots on the ground and in the background.

Grandpa's Girls

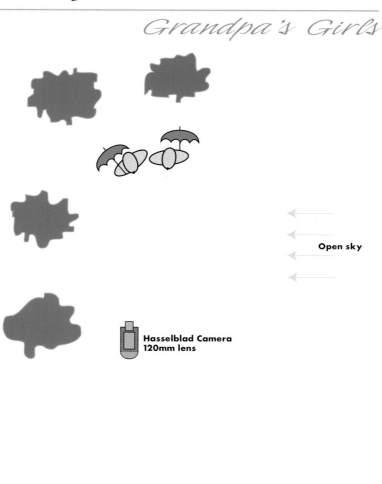

Open sky

Hasselblad Camera
120mm lens

I Christen Thee

POSE. This image was taken on the day after the actual baptism. That allowed me to bring lights into the church to make the image. The mother is holding the baby the way she did during the ceremony. The pastor was scheduled to meet us for the session. At the last minute, he cancelled due to sickness. Because of this, I stood in as the hand model. I had to use a long air release to trigger the camera. The baby's grandmother advanced the camera between exposures. Sometimes you have to make the best of a bad situation.

PROPS. The props are the baptismal font, the stained glass window, the water, and my hand.

PHOTOGRAPHY. The lighting is a Photogenic Portamaster, bounced out of an umbrella to provide the overhead light. A second umbrella, which is placed by the camera and off to the right a little, provides fill light. This lights the side of the subject facing the camera. The hard part is balancing the two light heads and the sunlight coming through the stained glass window.

Notice how some of the light from the umbrella providing backlight is bouncing out of the bowl, adding even more roundness to her face. I used a $\frac{1}{60}$ shutter speed to control the brightness of the window. A slower shutter speed would have made the window brighter in the photograph. In turn, a faster speed would have resulted in a darker window. The $\frac{1}{60}$ second exposure at f-8 provided just the right amount of illumination.

CAMERA. One of the great things about the Hasselblad is the optional Polaroid film back. Switching to this back allows you to test the lights and exposure. This is especially important when you are mixing light sources, as I did to create this image.

PSYCHOLOGY. The main psychology was convincing the mother that everything was going to be all right, even though the pastor was not there and I had to use my hand to place the water. This particular image created a lot of interest and generated several subsequent sessions with clients who wanted similar images.

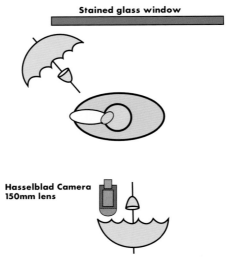

Stained glass window

Hasselblad Camera
150mm lens

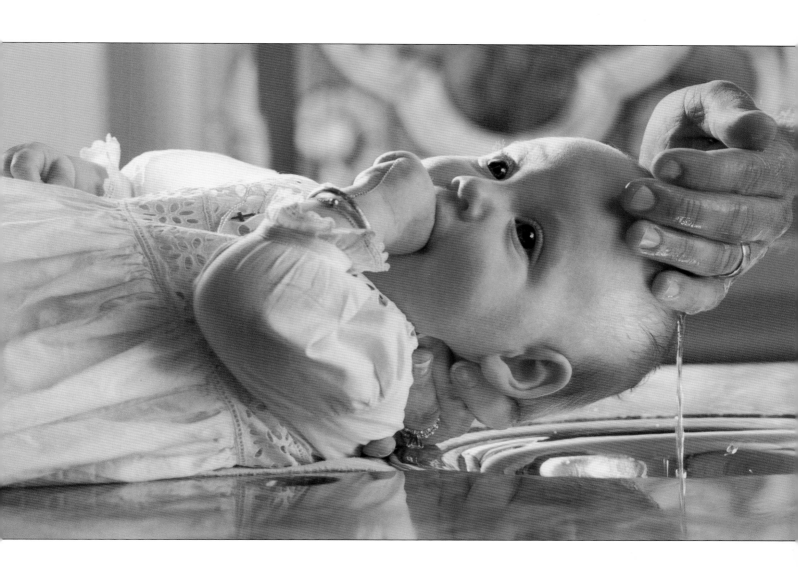

Flower Child

POSE. This pose is very natural for a little girl. As you can see, this little girl seems quite content standing here, holding the flower, and looking at it. This pose is simple, easy, and innocent.

YOU DON'T ALWAYS NEED COMPLICATED POSES TO CREATE A GREAT IMAGE.

You don't always need complicated poses to create a great image.

PROPS. The flower that the little girl is holding was growing in the area. It took her mind off me and the fact that we wanted to take her photograph.

PHOTOGRAPHY. This image was taken while the girl's family was on vacation. This is a great time to do photographs since the family will be in some new and exciting places. The background was comprised of hedges. The light was coming from the left and from above. By having the girl look down, we kept top light from being a problem. If the light had come from too high an angle, the natural shading from the girl's eyebrows and forehead would have caused her eyes to record darker. I call that "raccoon eyes." The film used was Kodak VPH. The exposure was $\frac{1}{60}$ second at f-8.

PSYCHOLOGY. This young lady did not want to have her photograph taken. We had done her family's photograph earlier and she was just about "photographed out." We took her to another area of the hotel grounds and tried to get her to think of something other than being photographed. I let her mom handle her, give her the flower, and do all the communicating with her. I find that the less you talk to children about taking pictures and the more you talk about having fun, the better the results.

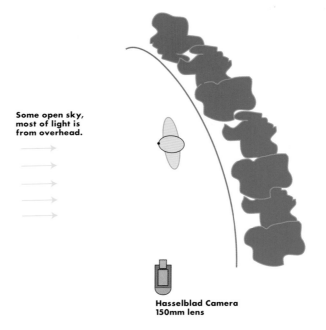

Some open sky, most of light is from overhead.

Hasselblad Camera
150mm lens

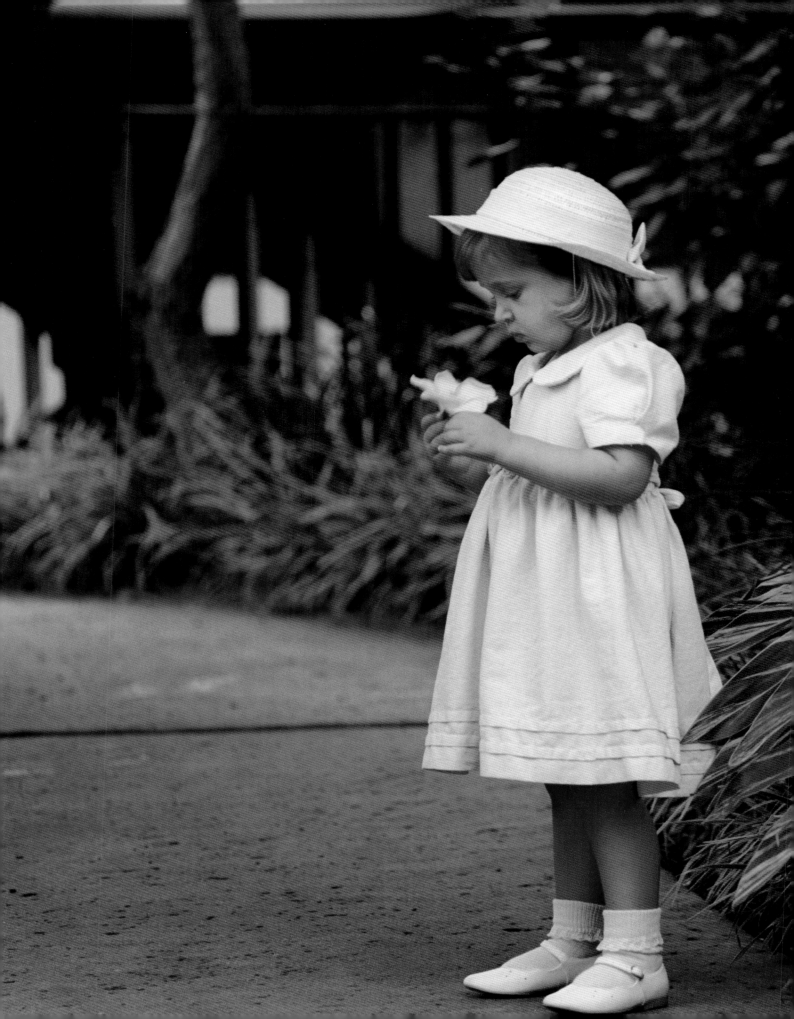

POSE. I turned this little lady away from me for two reasons: I wanted a profile, and I did not want to distract her. I asked the girl's mom to stand in such a position so that when the girl looked up at mom, I would get a good profile shot.

PROPS. I placed the watering can on the upside-down washtub. It seemed to go perfectly with the old wood of the shed, her outfit, and especially her hat.

BACKGROUND. I used a 250mm lens to throw the simple grass background out of focus. It also kept the swingset that was just out of lens range from showing.

PHOTOGRAPHY. Using the 250mm lens isolated the young girl against the background. Look at the nice lighting on her face. The

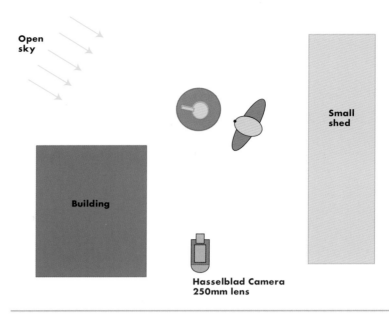

Little Gardener

great product. This film is processed in color chemistry but prints can be printed in a range of tones from a subtle blue tone to black and white to sepia tone. I chose this film for the nice sepia tone it can give. If you like to shoot black and white, but don't like the hassle of processing film yourself, or the expense

USING THE 250MM LENS ISOLATED THE YOUNG GIRL AGAINST THE BACKGROUND.

open sky provided the illumination. The building to the left blocked the light from the left and gave direction to the light. The exposure was $\frac{1}{60}$ second at f-5.6, the film used was Kodak T-Max 400 CN—a

of having the lab process it (black and white usually costs 20%–40% more than color processing), this film is for you! (Note: Since this image was shot, T-Max 400 CN has been replaced by Portra B&W 400.)

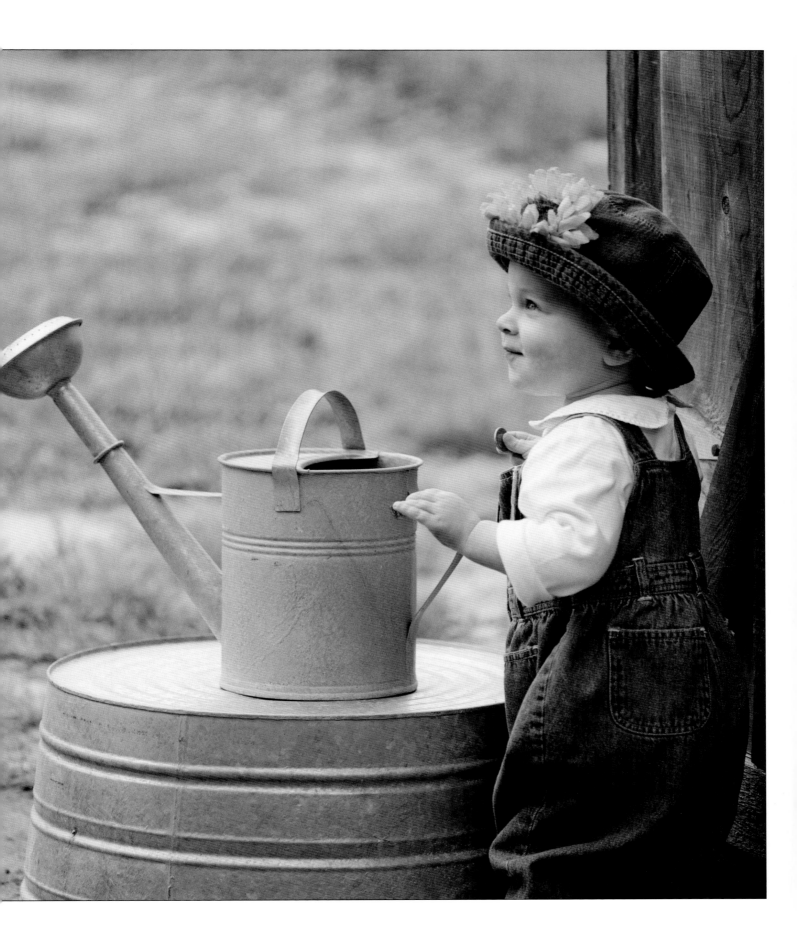

Praying

POSE. This is the first in a series of two images of a little boy kneeling by his bed. I typically do not like shooting straight into the shoulders, so I turned his shoulders slightly toward the camera to give a larger "base" for the head to rest on. I think this face (the side away from the light), and it keeps the light from falling on the lens. I have placed an X on the diagram. If you moved the camera to this spot and moved nothing else, you would have a perfectly lit ⅔ view of the face. The point here is in a ⅔ view. Experience has shown me that if I take the meter reading as if I am making the exposure for the X and open up one stop I have the proper exposure for a profile shot. The film used was Kodak VPS; exposure was 1/60 second at f-8.

THIS LITTLE TURN IS ONE OF THOSE SMALL THINGS THAT REALLY MAKES A BIG DIFFERENCE.

little turn is one of those small things that really makes a big difference.

PROP. This image was created in the boy's own bedroom. I like the "praying boy" picture on the wall. I let it go slightly out of focus and kept the light from directly hitting the picture. This keeps the attention off it, but it is still a secondary subject.

PHOTOGRAPHY. Notice the placement of the soft box and reflector. The reflector serves two purposes: it adds light to the dark side of the that in profile lighting, the lights are in the same position in regards to the face as

Larson 42" soft box

X Silver reflector

Hasselblad Camera 150mm lens

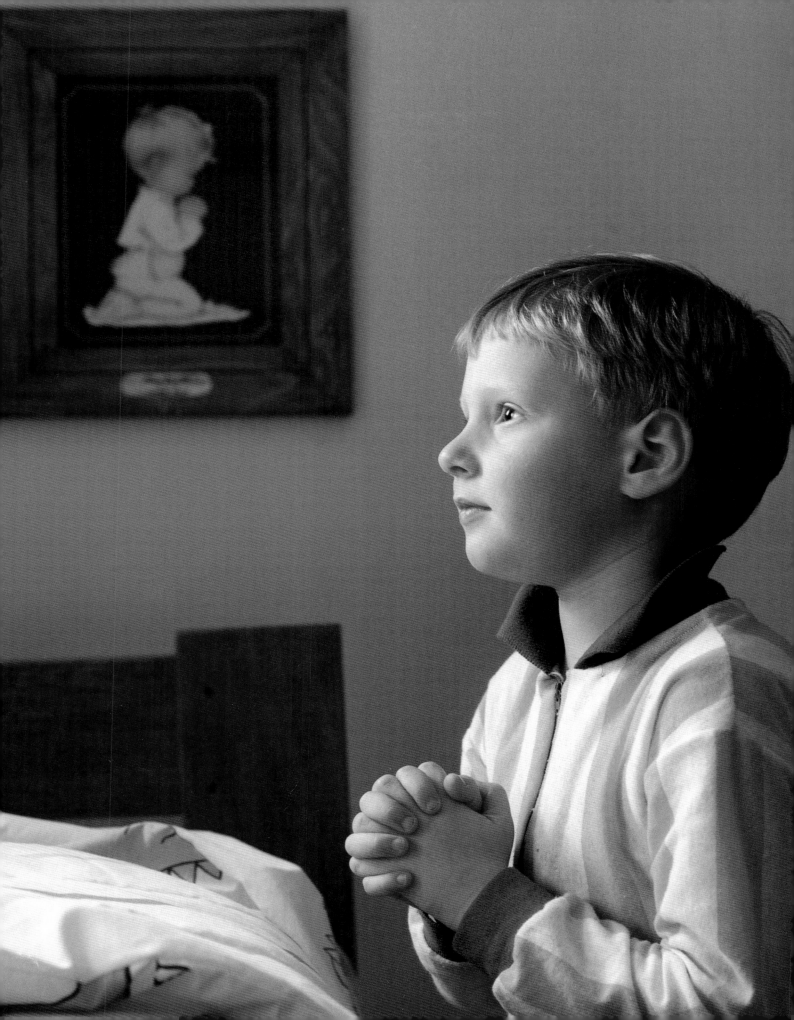

Really Praying

POSE. Here, I used the same setup with a different child. The pose is the same, too, but this boy turned his face a little more toward the camera, which worked out great. It added a lot to the shot. Sometimes you just get lucky!

TAKE YOUR METER READING BY PLACING THE FLAT DISK NEAR THE FACE.

PHOTOGRAPHY. Let me talk a little more about proper placement for a soft box and reflector. First, place the camera where you want it to get the profile photograph. Then, move yourself almost 90° to the left (to the X in the diagram)—this is where you would position the camera for a $^2/_3$ view. Now place the lights as if you were going to photograph this $^2/_3$ pose. The back edge of the soft box is placed a little in front of the subject's face. It is also turned so the main part of the light goes past the face and is aimed at the place the reflector will be.

Bring in the silver reflector approximately the same distance and position from the subject as the light. Then, turn the reflector back and forth until you have maximum light reflectance on the subject's face. Take your meter reading by placing the flat disk near the face, pointed right at the camera. Now, open the lens up one stop

and make the exposure for the profile position. You can use this formula for lighting many subjects. It provides a controlled lighting situation with good direction and a good contrast range. The film used was Kodak VPS. The exposure was $^1/_{60}$ second at f-8.

PSYCHOLOGY. This is the little brother of the first boy I photographed in this series. I told him to say a little prayer, then I told him pray really hard. This is the resulting photograph. You never know what you will get with children. This is why I love to work with kids—they are so uninhibited!

42" soft box

X

Silver reflector

Hasselblad Camera
150mm lens

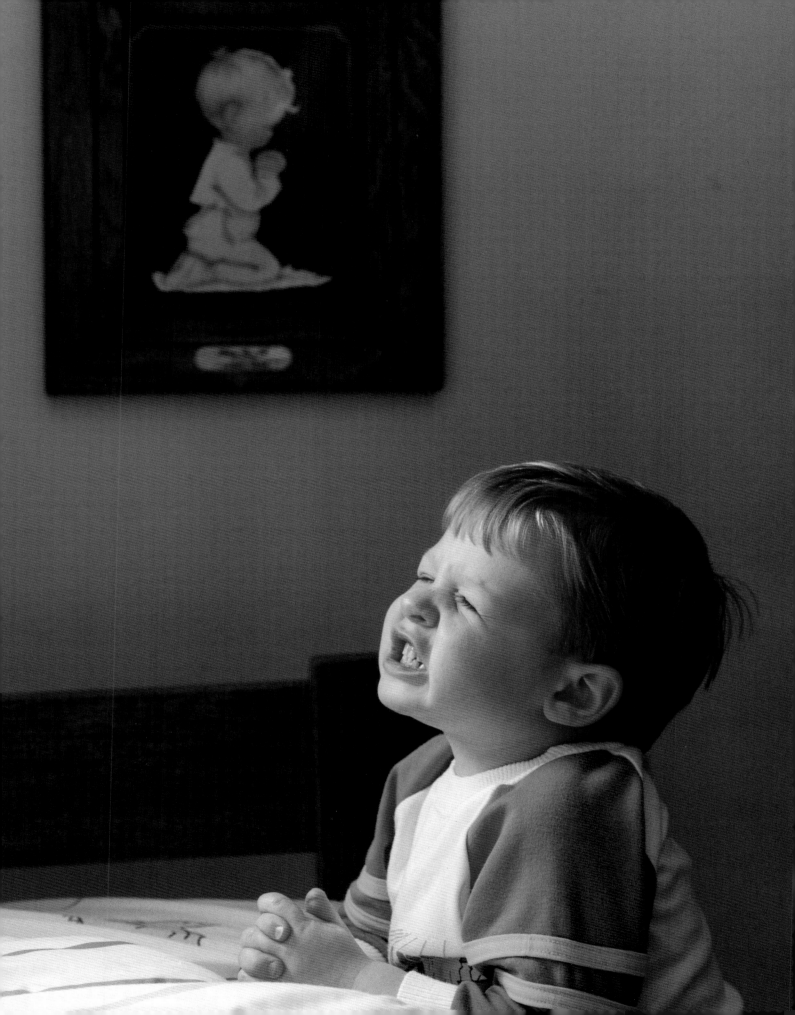

Pastel Bluebonnets

POSE. Posing brothers and sisters together can be difficult, so keep the poses simple. Make sure each person is in a good pose separately, then bring them together. In this image, the young lady has placed her weight on her back (left) foot. Her front foot is extended slightly.

PROPS. Each year I get dozens of calls from clients who want their families to be photographed in these large fields of bluebonnets (the Texas state flower). The background here doubles as a prop; I just let the children pick or hold flowers. Note that the subtle tones in the children's clothing keeps your attention away from the outfits and on the subjects.

BACKGROUND. The problem with these flowers is they only grow in bright sunlight. To get these rich colors I shoot in the late afternoon. When I took this image, the sun was setting just behind the children. A bank of trees located directly behind the subjects gave the light some direction. Just a few minutes earlier, the sun was shining harshly on the children and the background. I waited a few minutes for the sun to go down, and the saturation of the colors was increased.

PHOTOGRAPHY. The narrower angle of view of the 250mm lens put the background out of focus, isolating the subject more than a shorter lens could. It also showed less of the background, creating the illusion of a larger field of flowers. Using a tripod and cable release (as well as the mirror-up release, if your camera has it) will help you increase the sharpness of your images, especially when using telephoto lenses. The exposure I chose here was $\frac{1}{30}$ second at f-5.6.

PSYCHOLOGY. To be successful in photographing children, you must be able to read the moods of the children you work with. I usually talk to children like they are adults. They are much more intelligent and perceptive than most people give them credit for. Level with them. Tell them what you need them to do. Tell them how long it will take. Then have fun with them. Don't make it boring. Let them become involved in the process. Ask their opinions on how they would like to be photographed. You will be surprised at what they come up with.

Eastern light

Hasselblad Camera
250mm lens

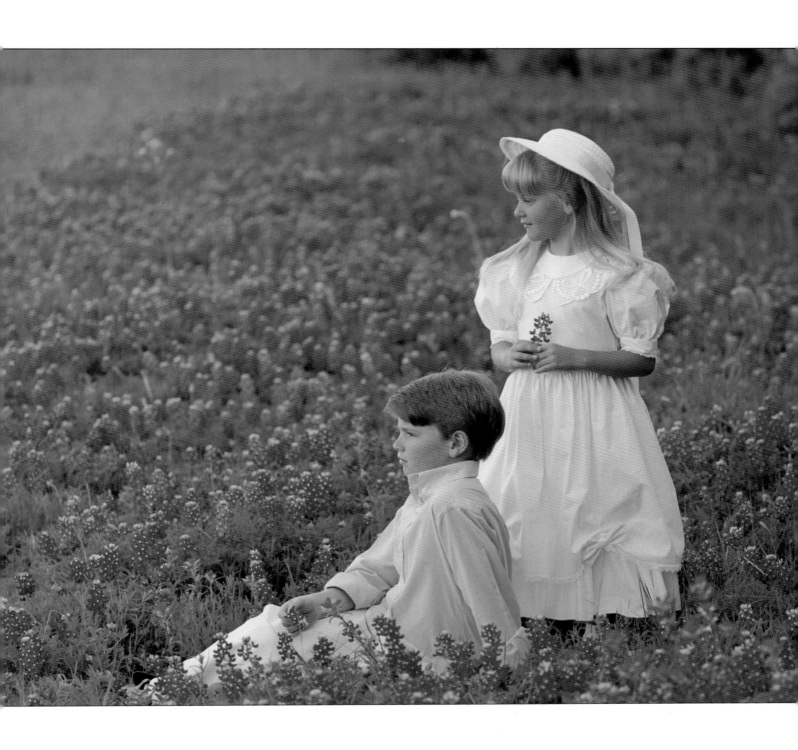

PHOTOGRAPHY. To create this portrait, I had the mother hold a reflector to block the sunlight from directly hitting the girls. I metered the light outside the doorway and set the camera for that exposure. I used the spot meter function on my Sekonic L-508 meter. The

I METERED THE LIGHT OUTSIDE THE DOORWAY AND SET THE CAMERA FOR THAT EXPOSURE.

The Doorway

lighter image (this page) is the way the lab printed it originally. I visualized it more like the darker image (opposite page), so I sent the negative back and ask them to "print it down." This is still a machine print, it is just printed darker. Look at the difference in the feeling of the two images. Many times, the lab can change the density on the print. Just ask if they can print it differently.

The film used was Kodak PPF; exposure was $\frac{1}{60}$ second at f-5.6.

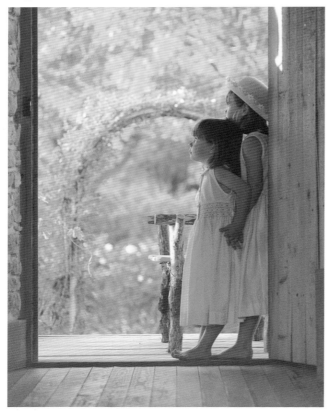

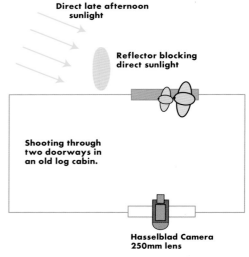

Direct late afternoon sunlight

Reflector blocking direct sunlight

Shooting through two doorways in an old log cabin.

Hasselblad Camera 250mm lens

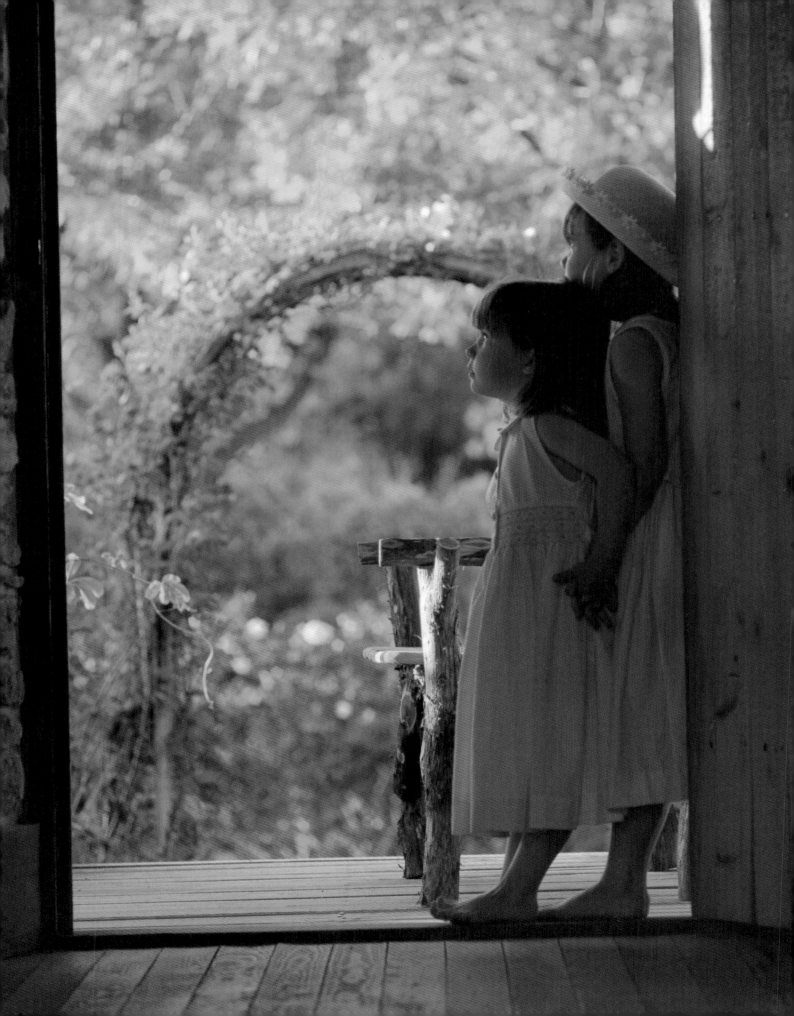

Beautiful Sky and Buggy

POSE. Separating this little girl's feet lent a real stability to the pose and created a sense of strength. I felt this

THIS MADE THE CHILD SEEM SMALL IN A GREAT BIG WORLD.

strength balanced the strong composition I used in the image. I placed the child in the lower right-hand third of the image. This made the child seem small in a great big world. I placed a lot of space in front of the child. This gives the subject room to move in the picture, and provides a more pleasing feeling to the image.

PROPS. Mom brought the buggy and the bunny. Yes, there really is a small pet rabbit in this buggy. This pet certainly kept its owner preoccupied—she had better things to think about than being photographed! The simple clothing adds to the peaceful feeling of this image.

PHOTOGRAPHY. Here, early morning light was soft, and the clouds added to this softness. I wanted to enhance the feeling of the stormy-looking clouds, and knew I could have the lab burn in on a custom print (burning in is a darkroom term that refers to darkening part of an image by allowing more light from the enlarger to fall on that particular part of the

Buggy

**Hasselblad Camera
120mm lens**

image). However, I wanted to be able to make a machine or automated print, which would save the client money. I opted to use a half gray Coken filter held in front of the lens. This darkened the sky and added a little drama to the image. The film used was Kodak PPF; exposure was $\frac{1}{60}$ second at f-8.

PSYCHOLOGY. This young lady was quite cooperative. I had worked with her before and had established a good rapport. We talked about her rabbit and what he was doing in her buggy. To get her to look off, I asked her if she could see another bunny off in the grass. She looked and we got the image we wanted.

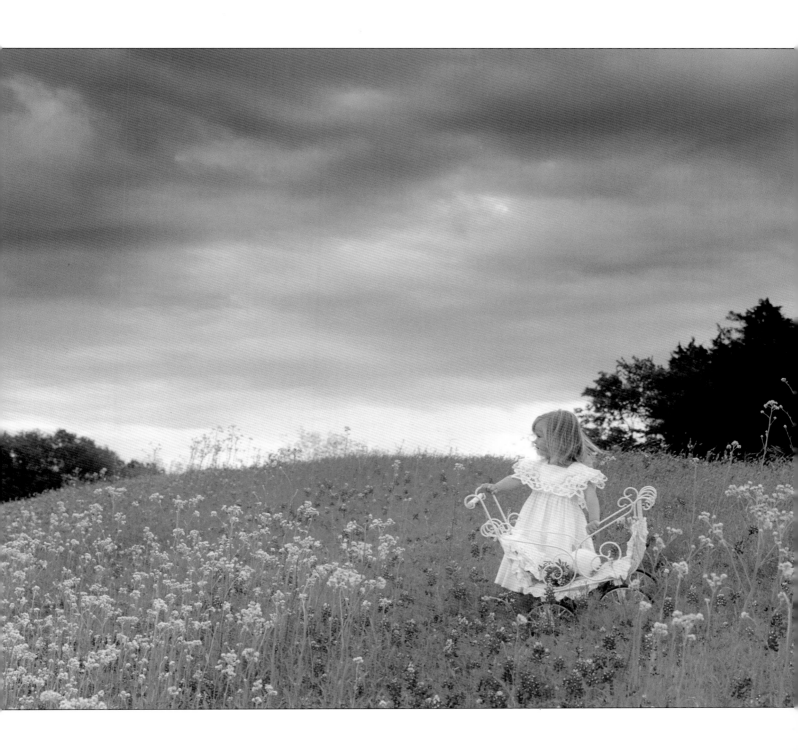

POSE. When we set up this family session, we planned to shoot images both with and without the horses. When we had finished the "without the horses" portraits, Dad and the boys went to get the horses. I was visiting with Mom when I looked up and saw them walking back with the animals. "Stop!" I shouted. With just a little direction we were able to create this outstanding image. I especially love the interaction between Dad and the youngest boy.

PROPS. The horses are an important prop, but the clothing is even more important. You probably wouldn't even notice the clothing unless it was pointed out—and that's great! The picture is about the people, not their clothes. I know it sounds a little old fashioned, but when everyone is dressed alike, the image is nicer.

PHOTOGRAPHY. I used the 250mm lens in this image to throw the background out of focus, making it less distracting. The bright sky at the upper right-hand area of the image is still a little bit distracting, but this could easily be cropped. I metered

Direct sunlight from late afternoon sun

Open sky

Hasselblad Camera
250mm lens

this image the way I almost always meter, with the flat disk pointed directly at the camera. I use the Sekonic L-508 Zoom Master, which is both a reflected light and incident meter. The reflected meter is a 1°–4° zoom spot meter. Its retractable dome can be used as a flat disk. For this image, I used the flat disk to read the light falling on the front of the subjects.

The flat disk is great for this; if I had used the dome, some of the direct sunlight would have hit the dome, causing an underexposed negative.

THE HORSES ARE AN IMPORTANT PROP, BUT THE CLOTHING IS EVEN MORE IMPORTANT.

The spot meter was used to read the sunlight falling on the subjects. Because it was only two stops brighter than the light on the faces of the people, I knew it would not blow out the highlights.

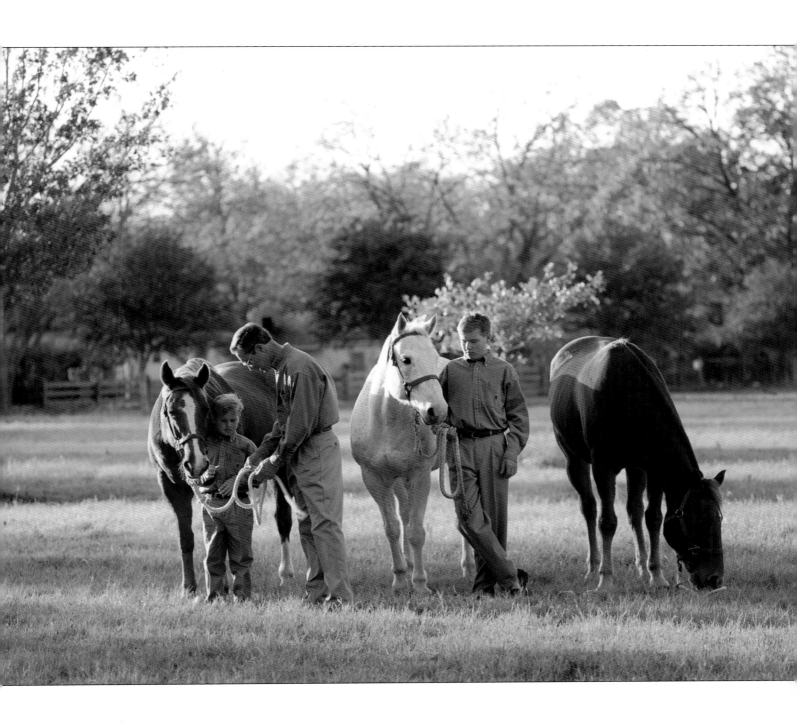

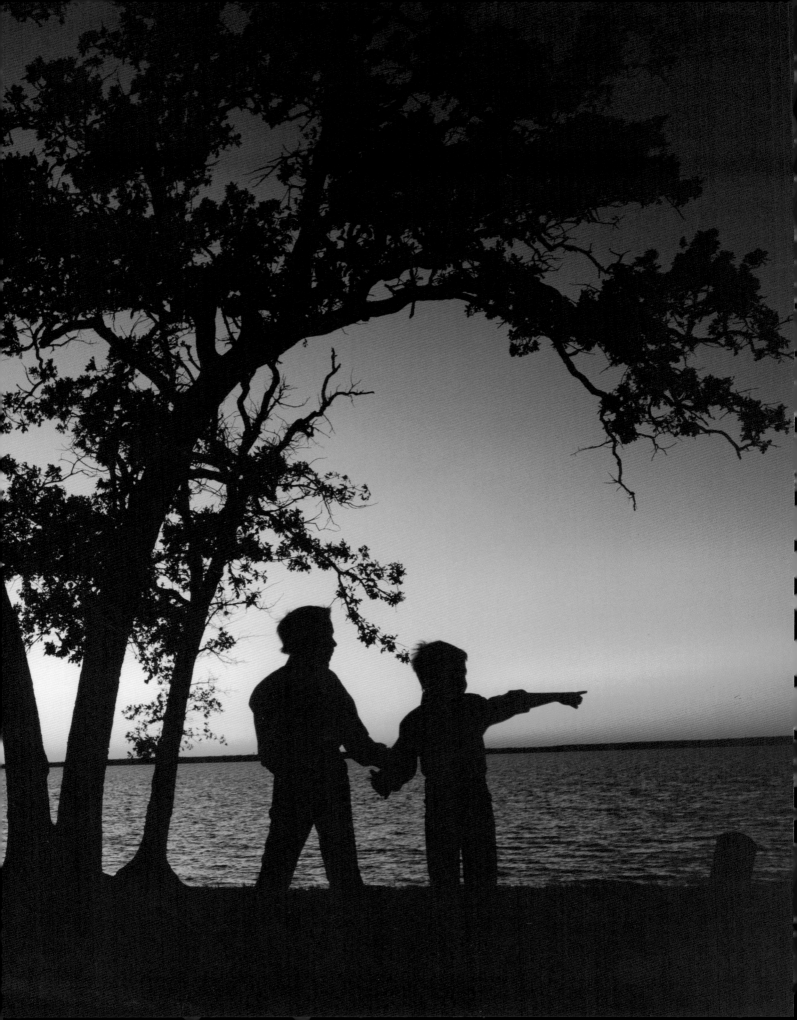

Silhouette Boys

POSE. If you leave children alone, they will probably pose themselves. This pose shows how the two brothers feel about each other, as well as the adventure and wonderment of little boys.

BECAUSE YOU CANNOT SEE THE SUBJECT'S FACES YOU CAN CONCENTRATE ON WHAT IS HAPPENING.

PROPS. The sunset allowed for the silhouette that makes the image dramatic. Because you cannot see the subject's faces you can concentrate on what is happening.

PHOTOGRAPHY. A scene like this has a large range of tones, and extremes in contrast, from very light to very dark shades. The best way to meter this is with a reflective or spot meter. Most 35mm cameras are equipped with a reflective meter. If your camera has an averaging metering system, it will take the entire range of tones and average them to give you a reading. A spot or center-weighted meter can single out a small section of the scene from which to take the reading. Make your reading from whatever part of the scene you wish to emphasize. In this case it was the middle tones of the sky.

PSYCHOLOGY. Photographing your own children often requires as much patience and planning as photographing other people's children. On this occasion, I asked my sons if they wanted to go to the lake. Going to the lake sounds like more fun than taking pictures, and I wanted to make the day a great, memorable experience. I told them, "While we are there let's take some pictures. David, you can take some pictures of Derrick, and Derrick, you can take some pictures of David." While helping them photograph each other, I made images for myself. We had a picnic dinner, played on the playground equipment, took a nature walk, and did portraiture in between. The sun began to set and the sky turned a beautiful golden orange. The last few images were made while the boys were being the inquisitive, adventurous boys that they are. A beautiful, memorable portrait topped off a great experience.

Tree

Lake

Hasselblad Camera
150mm lens

Three Brothers, Dark Shirts

POSE. This is a two photograph series. This first photograph is a simple half-length portrait of three boys. The older boy is sitting on a

WHAT MAKES THIS IMAGE IMPORTANT TO STUDY IS THE CLOTHING.

small bench, the youngest standing, and the middle boy is leaning an arm on his knee. What makes this image important to study is the clothing.

PROPS. The boys' outfits are the props in this image. When we first talked to the boys' mother, she mentioned that she had selected dark shirts for her sons to wear during the session. It seems that another photographer had told her to dress the boys in dark clothing. We told her it was okay to bring these shirts, but asked if she could also bring matching outfits—something like blue denim. We took a series of photographs in the dark outfits, then had

the boys change into the matching outfits. I think you will agree that the image on page 77 is much nicer, mainly because of the clothes!

BACKGROUND. The boys were posed outside by a bank of large evergreen bushes. The small bench is made from a large slab of rock resting on some smaller rocks.

Eastern light

**Hasselblad Camera
250mm lens**

PHOTOGRAPHY. I used a 250mm lens to isolate the subjects and to break up the hot spots in the background. I used Kodak PPF, a film I love (especially the 400 speed) and count on.

PSYCHOLOGY. When I work with older children, I treat them with an extra measure of respect. I let them know what to expect from me, including know how long the session will take. I tell them that I don't expect them to smile all the time, and that I want to do some images for their mom, some images for me, and some images just for them!

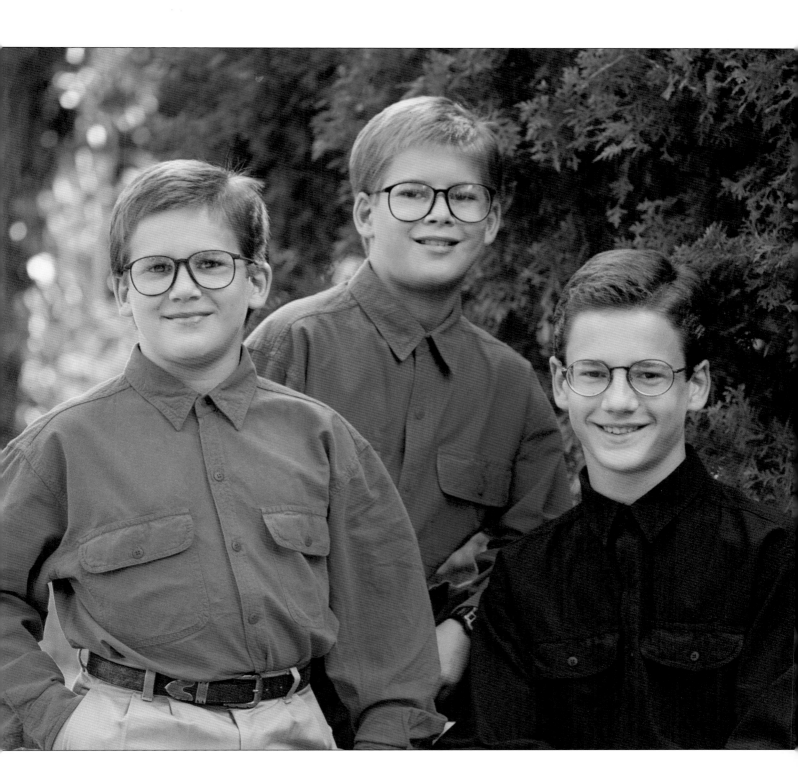

Three Brothers, Better Choices

POSE. My goal in posing the boys in this image was to place their heads at different levels. Thus, I asked one boy to sit on the fence, one to

I PREFER THAT SUBJECTS WEAR PANTS AND SHOES THAT ARE DARKER THAN THEIR SHIRTS.

kneel in front of it, and the third to stand behind it. I like to work with triangular compositions like these.

PROPS. I prefer that subjects wear pants and shoes that are darker than their shirts. This keeps the viewer's eyes from bouncing between the faces and the lighter-colored areas. One of these boys was wearing dirty shoes, so some retouching on his shoes was needed in the enlargement.

BACKGROUND. This is just a corner of a split rail fence at the studio. It has proven to be a very versatile prop that works great for children, families, seniors and groups. It can have a western flair or just a country setting.

PHOTOGRAPHY. If you look closely at the boys' eyeglasses, you can see what is commonly called "glass glare." I did not have it removed for the book so that you could see what it would look like in this situation. There are a couple of ways to remove or retouch this. One is conventional dry-dye spotting of the light colors in the glass-

es, to match the dark colors around the area. However, with the digital imaging software now available, glass glare can be taken care of digitally. Burrell Color, the lab that printed the images for this book, can scan your negative into their computer system. They can clone the areas around the glare, replace the "glare" area with the proper color, and completely remove the problem. They then output the electronic file to a new negative. This new negative can be printed by conventional means, which is especially great if you need to print several prints from the same negative.

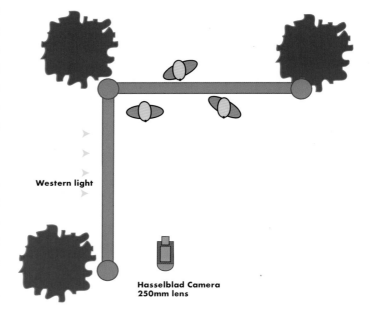

Western light

Hasselblad Camera
250mm lens

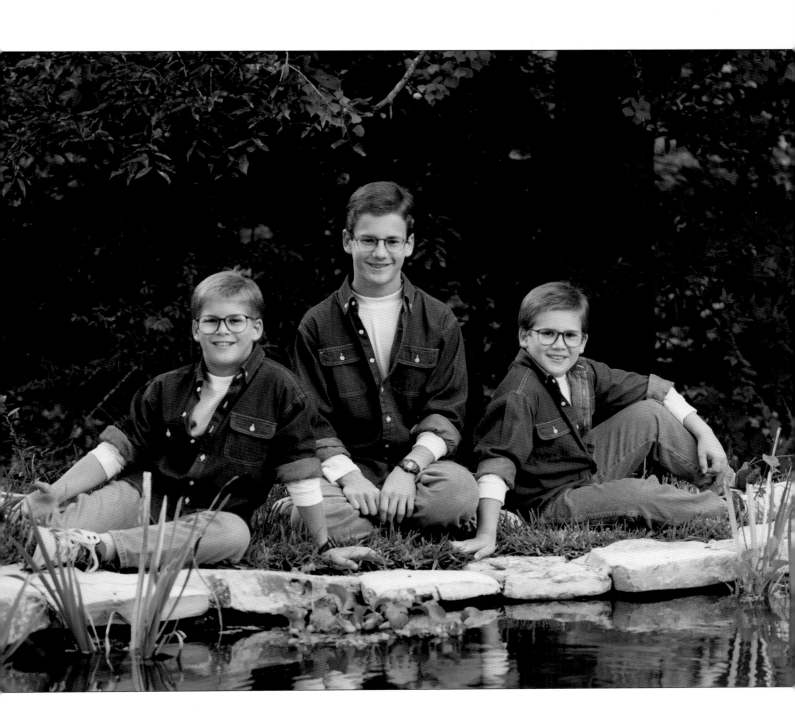

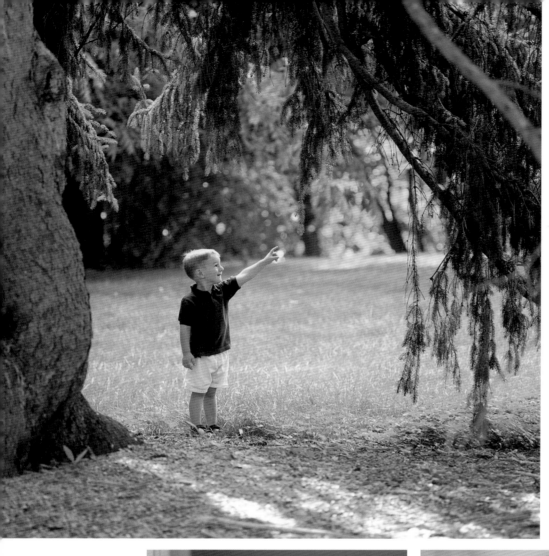

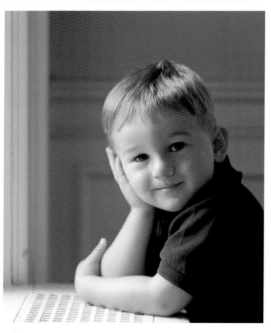

PERSONALITY. One of the things I try to do when I photograph children is to capture the different sides of their personalities.

In the window light portrait (bottom, left), I wanted to show this little boy's quiet side. I love the way his little hand rests on the side of his face.

In the photograph with the young boy standing and pointing (top), I placed the young man in a location where the dark tree trunk and branches would frame the lighter area in which he was standing. This makes the boy the focal point of the image, even though he is rel-

Strong-Willed Child

LIGHTING. One of the most important aspects of outdoor photography is finding the right light. You will notice in the close-up that the light is coming from the right. There is a large tree on the left side of the photograph that is blocking the light from that side. There is also a large patch of open sky on the right side. It is very important that you have an

10 o'clock position in the eyes. It is also important that there is a catchlight in *both* eyes; these let you know that there is light in both eyes.

YOU HAVE TO POSITION THE SUBJECT SO THAT THE LIGHT FALLS ON HIS FACE PROPERLY.

atively small in the frame. When I asked him "Where is the roof?" he just pointed. The result is a fun shot.

PHOTOGRAPHY. Look at the close-up of the little boy outside (bottom, right). I chose the 250mm lens to isolate the young fellow from any distractions in the background. Also notice how it isolates him from the leaves that are right in front of him.

area of blue sky on one side to provide illumination.

POSING. Once you have found the area of sky to give you the light, you have to position the subject so that the light falls on his face properly. Look for light in both eyes. In fact, look for catchlights (catchlights are the bright spots in the eyes that made by the light source) in the 2 o'clock or

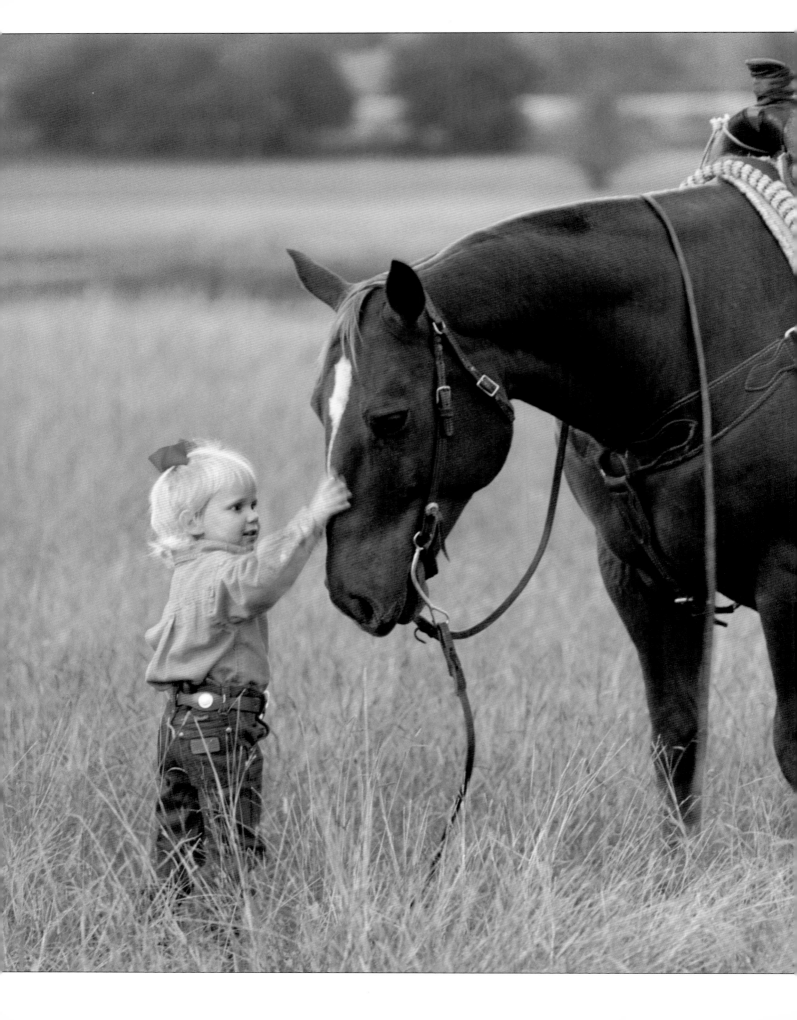

POSE. Believe it or not, this little girl rides this horse all the time. We did a series of images, from her feeding the animal to simply holding the reins. This was my favorite. It seems so natural. I certainly did not have to encourage the horse to eat!

PROPS. I asked the mom to dress the youngster in simple clothing. Many times western clothing can be quite bold. I think the simplicity of the outfit adds to the overall feel of the photograph. The horse is hers, the image was taken on the family's property. I enjoy the scale of the image—the large animal with the very small child. I also like the space around the subjects.

PHOTOGRAPHY. The time of day the image was taken is what makes the lighting quality so beautiful. At the time this image was shot, the sun had already gone down and the light value was low. A tripod, 400 speed Kodak PPF film, and my Hasselblad's mirror lockup feature made it possible to use a 250mm lens to obtain this image. The mirror lockup feature really added sharpness to the photograph;

Little Girl and Her Horse

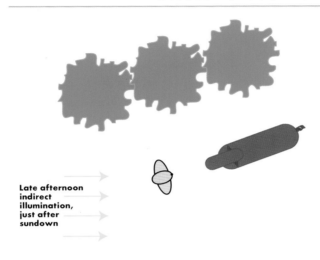

Late afternoon indirect illumination, just after sundown

**Hasselblad Camera
250mm lens**

using a cable release during long exposures will also help to reduce camera movement.

THE MIRROR LOCKUP FEATURE REALLY ADDED SHARPNESS TO THE PHOTOGRAPH.

The exposure was wide open, f-5.6 at ¹/₃₀ second—quite slow for this long lens.

PSYCHOLOGY. We did family photographs a few minutes earlier, and used riding the horse as a reward. I did some images on the horse—we had promised the little girl she could sit on the horse, so we had to come through! Next, we coaxed her to get down and feed the horse. As you can see, it worked.

Just the Faces

POSE. Sometimes the simplest pose is the best. This baby is simply laying on her mother's bed, propped up by pillows.

I MOVED UP CLOSE TO CAPTURE JUST THE FACES AND THE EXPRESSIONS.

PHOTOGRAPHY. The lighting is coming in from the left through a window. The light was indirect sunlight. I was testing Kodak's TMZ 3200 speed black and white film. The high ISO film let me handhold the camera. This lets me work fast and capture images quickly. The exposure was $\frac{1}{250}$ second at f-8. The Nikon 8008S is a great camera for this type of photography because it focuses quickly and the computer in the camera is able to average the light and give great exposure, allowing me to concentrate on the subject instead of the camera. I moved up close to capture just the faces and the expressions. When I presented the image to the client, the three

prints were printed side by side in a horizontal arrangement. It was printed on watercolor paper by Pacific Color on an Iris printer. The images were about 5" x 7" in size on a 10" x 28" piece of paper. The

overall presentation was wonderful. I especially love the middle image. Look at those eyes!

PSYCHOLOGY. I love working with babies. I seem to be able to get good expressions. Maybe I have a funny face to babies. I like to get in close and make soft kissing sounds and then move back quickly. I talk softly and laugh a lot with babies. It seems to calm them. Then you can whistle or make a funny sound and you might get the middle expression, but be quick—it won't last long!

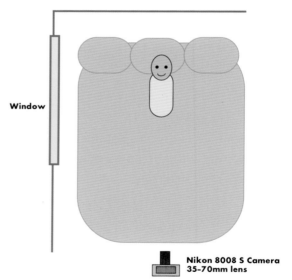

Window

Nikon 8008 S Camera
35–70mm lens

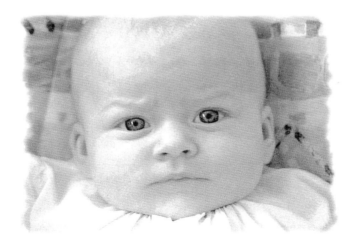

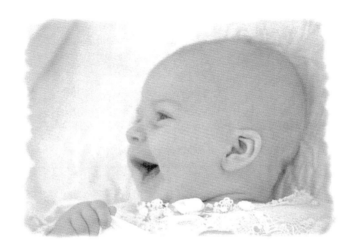

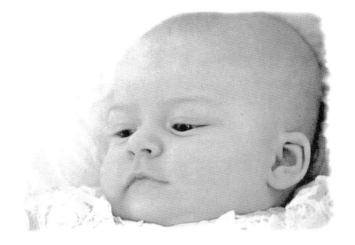

Wildflowers (Two Different Lighting Situations)

PHOTOGRAPHY. The two major differences between these two images are time of day and lens selection. The image of the mom and two boys was taken a little earlier in the day than the other image. Notice the sunlight hitting the subjects: it has a warm, spontaneous feel. I like the lighting on the subjects, but the color of the bluebonnets in this image is not as rich as it appears in the other image. I used a little fill flash to fill in the dark side of the mom's and boys' faces. Without it, the side of the faces closest to the camera would have been darker.

The image with the bunny was created after the sun was down below the tree line. This "open shade" provides a more even lighting situation and increases the saturation of color in the background. Look at the subtle direction of light on the children's faces. You can see that the 250mm lens I used in this image compressed the background. While the first image shows an expansive field of flowers, the second image seems to depict a more intimate setting. The film used was Kodak VPS.

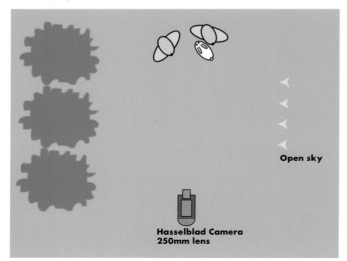

Open sky

Hasselblad Camera
250mm lens

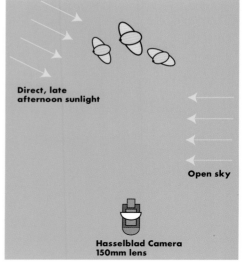

Direct, late afternoon sunlight

Open sky

Hasselblad Camera
150mm lens

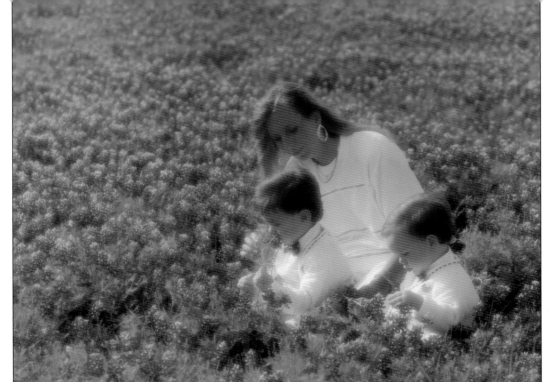

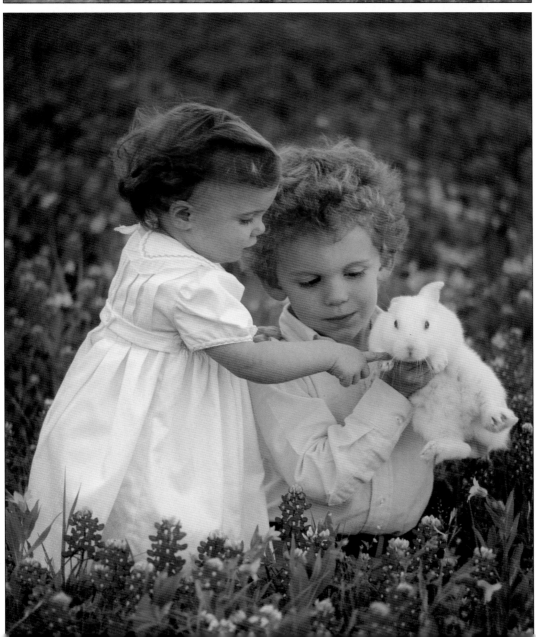

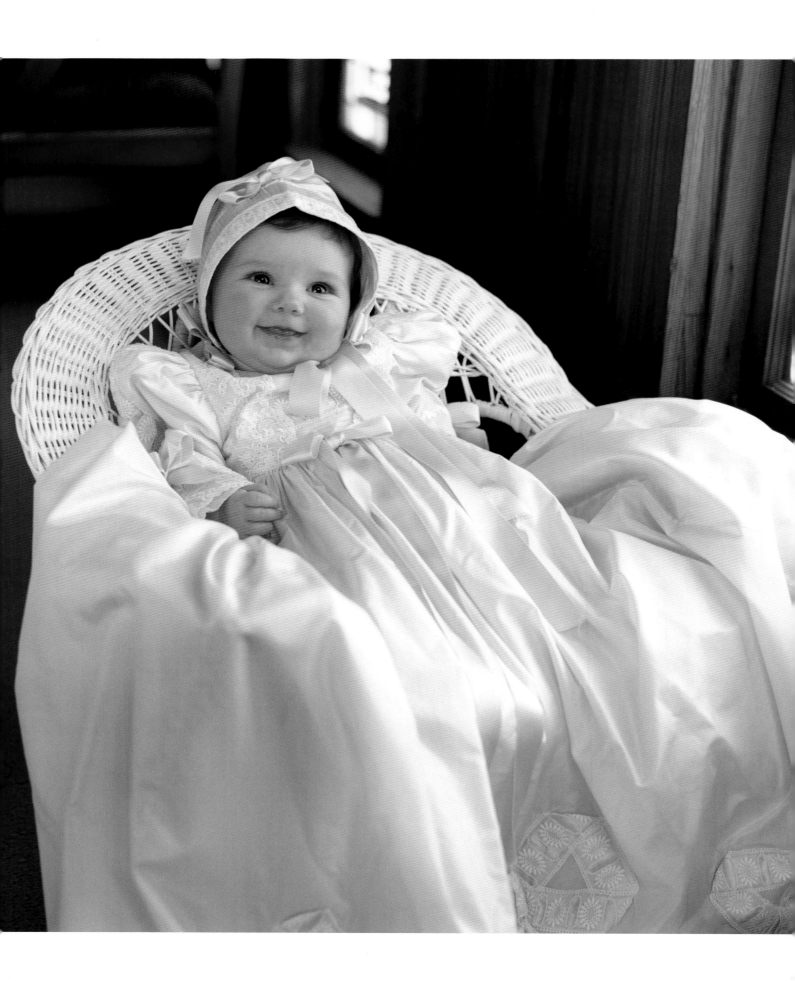

POSE. This pose works great for small babies. I simply placed the baby in the wicker chair and adjusted or propped her up until she was in the right position. Using this prop allows the baby to almost sit up—even before she can't do so on her own. For this christening portrait, I just draped the baby's gown over the arms of the chair.

LIGHTING. I chose to place the baby near a window for proper illumination. The light was a little too contrasty, so I used a gold reflector on the left to fill in the shadows. If you look closely, you can see the catchlights from the reflector at the

Window Light Christening

BACKGROUND. We chose to do this baby's portrait at the church where the christening took place. That gave the image more emotional impact. The stained glass windows provided the illumination for the portrait.

PSYCHOLOGY. I usually request that parents not bring relatives and friends to the portrait session. Extra people only serve as a distraction and result in poor

It is also helpful to specifically request that the parent and child be ready for their session on time. Lateness causes us to rush, and since we want the best for our clients, we don't want to rush a portrait session. If the child is not feeling well or is in a bad mood, we might ask the client to make a new appointment for another day.

THE LIGHT WAS A LITTLE TOO CONTRASTY, SO I USED A GOLD REFLECTOR ON THE LEFT.

8 o'clock position in the baby's eyes.

PHOTOGRAPHY. I chose a low camera angle in order to put the viewer more on the level of the child. Many times, adults will photograph children from adult height. As a result, the images seem to "look down" on their subjects.

portraits. Be sure to ask that parents leave other children with a sitter. Choose the time of day when the child being photographed is the happiest and at his very best. Never schedule a portrait session near nap or mealtimes.

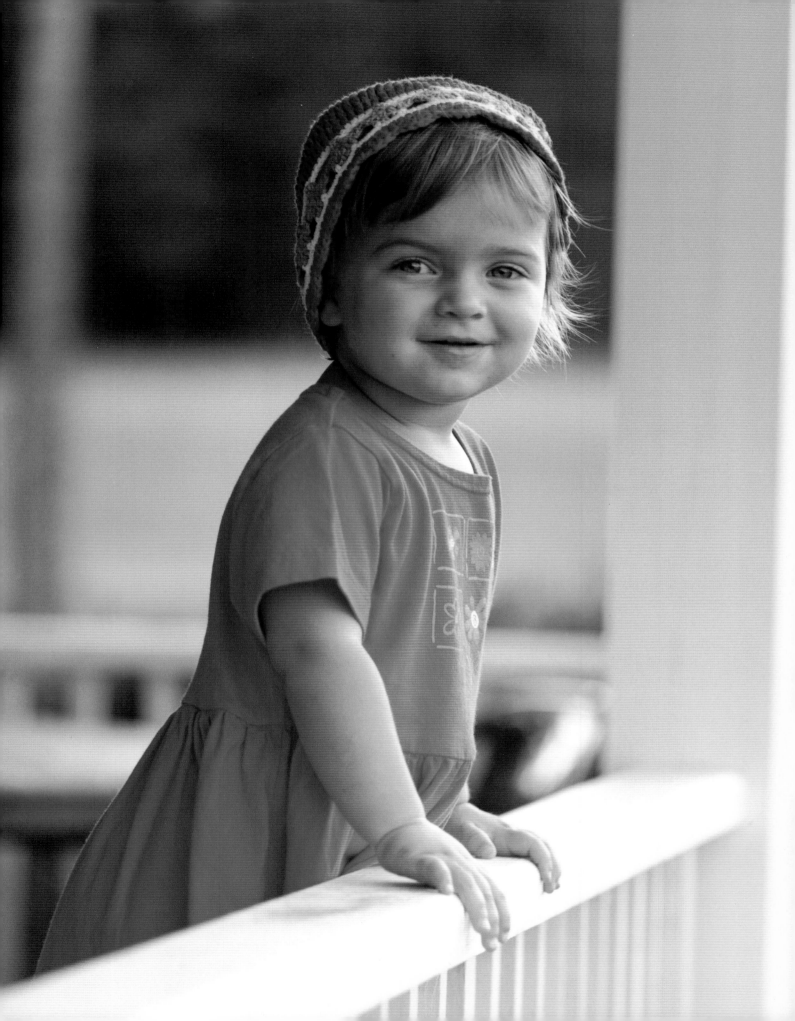

Pink on the Porch

POSE. I had this little girl stand on a small bench in order to bring her to the right height for the rail. The camera was already set up and prefocused. As soon as the dad placed the child on the bench, I began to play

I LOVE THE DELICATE WAY SHE IS PLACING HER RIGHT HAND ON THE TOP RAIL.

peek-a-boo around the camera. She lit up with this beautiful, natural expression. I love the delicate way she is placing her right hand on the top rail. Sometimes you just get lucky with children.

PROP. The little girl's mom brought this beautiful knit hat to the session, and asked if she could include it in a couple of photographs. When I saw the hat I knew it would photograph very well.

BACKGROUND. This little girl is standing on the porch of a 100-year-old bed and breakfast in the country, where the family was staying.

PHOTOGRAPHY. Using a 250mm lens throws the background totally out of focus and compresses the railing. All of this helps isolate the subject. This image was taken in late afternoon, about one hour before sun-set. The exposure was $\frac{1}{60}$ second at f-5.6; the film used was Kodak PPF.

PSYCHOLOGY. Many times, playing a simple game of peek-a-boo with a small child will prompt great expressions. This little girl and her family were staying at an old bed and breakfast when this photograph was taken. Vacations are a great time to do portraits. Your clients are generally in a really great mood and there are a lot of beautiful photographic opportunities. Make sure that your clients bring appropriate clothing to the session. Solid colors or very simple patterns usually photograph best.

House

Porch

Western light

**Hasselblad Camera
250mm lens**

POSE. If you look closely at the upper right-hand corner of this image, you can see that the youngest girl is sitting on her mother's lap. This kept her still and kept her from falling. I just brought the two sisters together and waited for the right moment!

PROPS. Sometimes my favorite images are the simplest. This one captures the innocence and wonderment of childhood. It shows the relationship between sisters and the excitement that you can put on film.

PHOTOGRAPHY. This is another example of what you can do with a 35mm camera and window light. Window light is coming in from the

> THIS IS ANOTHER EXAMPLE OF WHAT YOU CAN DO WITH A 35MM CAMERA AND WINDOW LIGHT.

right and some is coming in from behind me. I set the Nikon 8008S on program. Even though there was a lot of white in the clothing, the darkness in the background ensured that the metering system was not tricked into underexposure. If you have a scene that is all white or all black you will have to adjust the exposure compensation

**Nikon 8008S Camera
35–70mm lens**

control to account for this. Remember, all reflective meters are set for gray—18% gray to be exact. When a meter sees all white, it "thinks" this is gray with too much light on it. It then cuts down on the light hitting the film by changing the f-stop or shutter speed. In contrast, when a meter sees all black, it tries to make it gray by letting in more light. The result in this case is overexposure. The film used was Kodak TMZ 3200 rated 3200; exposure was $1/125$ second at f-8.

The Secret

PSYCHOLOGY. I have to confess that I got lucky this time. The girls' mother told the older girl to kiss her little sister and I quickly captured what followed. The images were printed on one sheet of watercolor paper by Pacific Color (see the resources section at the back of this book).

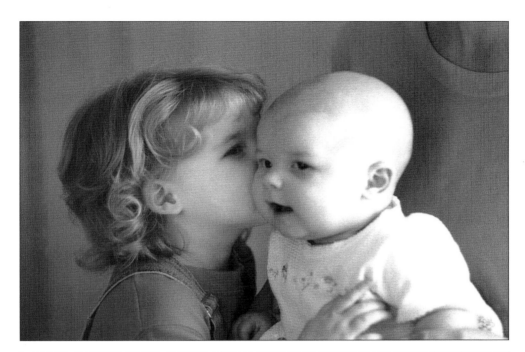

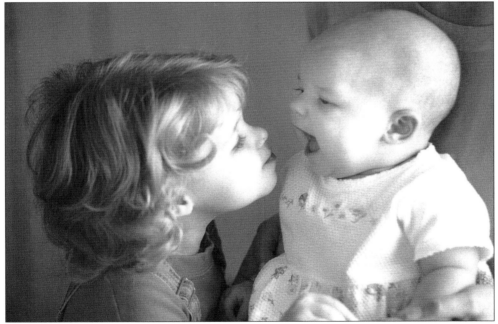

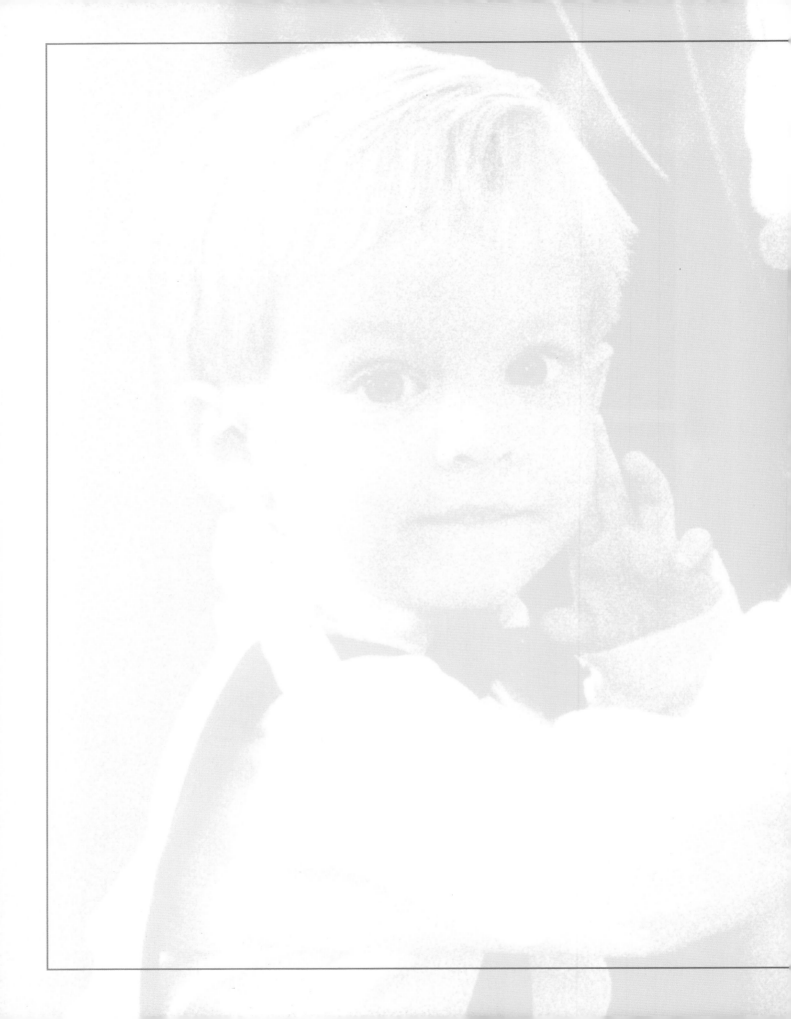

SECTION

3

WEDDING IMAGES

Among the most exciting products offered by our studio are black and white, documentary-style wedding photographs. About a year

high-speed TMZ 3200 film would offer the opportunity for Barbara to handhold the camera and shoot without a flash, allowing lots of cre-

ative freedom. What transpired next was pure magic.

Barbara's experience with art and architecture have helped her create beautiful images. She felt inspired by some of the images of Dennis Reggie, Gary Fong,

BARBARA'S EXPERIENCE WITH ART AND ARCHITEC-TURE HAVE HELPED HER CREATE BEAUTIFUL IMAGES.

ago, my wife Barbara informed me that she was going to bring a second car to weddings. "Receptions are boring!" she insisted. "Please don't," I begged. "If you're not there, the receptions will be even more boring for me. Why don't you start taking some photographs?" I asked. I knew that Barbara enjoyed the detailed, close-up, and emotionally charged images, as well as the traditional images (especially the images of children) that I produced.

I knew that Barbara liked black and white images, and could operate my Nikon 8008S. I also knew that she had an artistic eye: she had studied both art and architecture. I realized that using

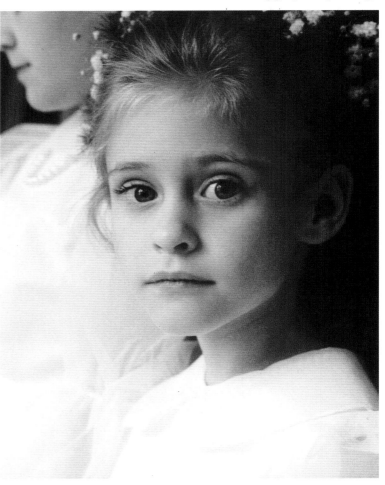

Laura Lund (and, of course, her husband!), and developed her own style! Concentrating on design, line, and form—along with emotion and excitement—she began creating dynamic images.

inspire others—especially female assistants and spouses that go to the wedding, but are not usually involved in the creative process—to try their hand at creating their own images. We've had

The images on this page and the next are examples of Barbara's work at some of the weddings we've shot together.

WE'VE HAD DOZENS OF LETTERS AND CALLS FROM PEOPLE WHO HAVE TAKEN OUR ADVICE . . .

Through the development of her unique images, she has proven that women see things differently.

As we teach seminars around the country, we

dozens of letters and calls from people who have taken our advice and had great success. I hope you'll try it, too.

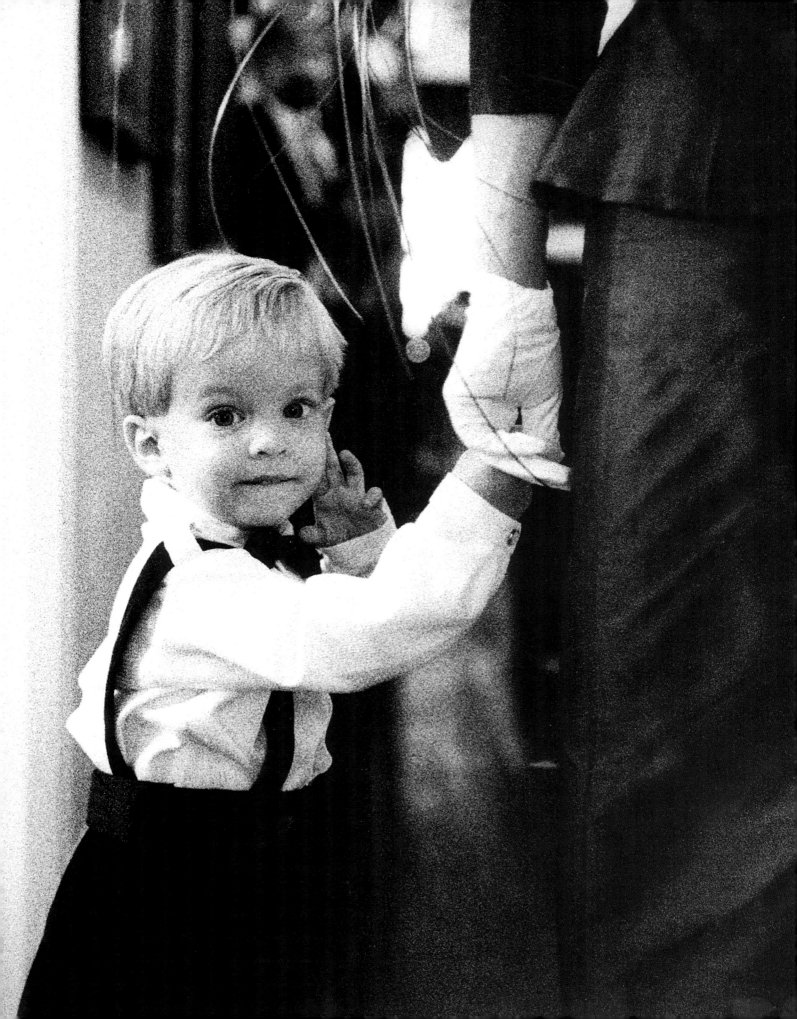

PHOTOGRAPHY. Technically speaking, the Kodak TMZ 3200 black and white film was exposed ISO 3200, push-processed one stop and

So far the results are very nice. It has less grain and can be printed in black and white or sepia tone. Instead of proofing all of the exposures,

the lab print only the best exposures. (I bought my Fujix at CHF; contact information is listed in the resources section at the back of this book.)

USING THE FILM AT THIS SPEED PRODUCES A BEAU-
TIFUL, NOSTALGIC IMAGE.

printed with a #3½ filter on Kodak PolyMax RC II paper, E surface. Using the film at this speed produces a beautiful, nostalgic image with a nice grain structure—perfect for the emotionally charged and artistic details at weddings. If you want less contrast, expose the film at 1600 and process regularly. This results in less grain and a softer look. If you are photographing in a contrasty lighting situation, use the latter combination. If the light is flat or you are shooting in a very low light situation, use the higher speed and push-processing.

We have experimented with the new Kodak T400 CN film, exposing at ISO 1250 and push-processing it.

we have the film processed, but not cut. We edit the film with the Fujix FV-7 and have

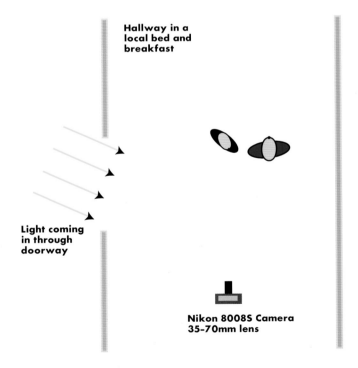

Hallway in a local bed and breakfast

Light coming in through doorway

Nikon 8008S Camera 35-70mm lens

Fill Flash

POSE. When photographing at a wedding, you have to work quite fast and with minimal equipment. I sat the young flower girl on this couch at the bed and breakfast where the wedding was held. I tucked her right foot under her left leg. This kept her legs from becoming too prominent in the image and allowed me to turn her a little more toward the window.

PHOTOGRAPHY. Film and photographic paper cannot always record a scene the way we see it. Sometimes the contrast range in a scene is more than the film can handle. That is when supplemental light is needed to bring the contrast levels in the scene into the range of the film.

To balance the dark foreground with the lighter background, I added light to the front of the subject, using a Quantum Q-Flash. This was mounted on the camera with a Strobo-frame flash bracket, which places the flash unit directly above the lens. This prevents unnatural shadows on one side or the other of the subject. I like the Q-Flash for several reasons. It utilizes an automatic eye that gives the proper exposure by controlling the amount of light the flash gives off. Also, the flash unit is adjustable in $^1/_3$ stops, which gives me a tremendous amount of control. The flash head rotates 180° vertically and 360° horizontally. I pointed the flash straight up toward the ceiling and placed my hand directly above the flash head, held at a 45° angle, to bounce some of the light toward the subject. The rest of the light hits the ceiling and bounces around the room providing additional illumination.

I read the light coming through the window hitting the girls' face. The ambient light hitting the plane of the subject facing the camera was four stops less. This was too much contrast for the way I visualized the image, so I set the flash one stop lower than the light coming through the window. While I like the small image—it is more moody—I knew the bride would probably like the large photograph. By learning to use the tools of the trade I was able to create both.

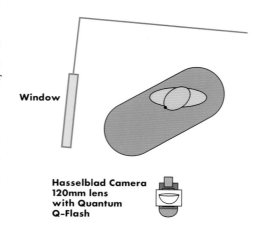

Window

**Hasselblad Camera
120mm lens
with Quantum
Q-Flash**

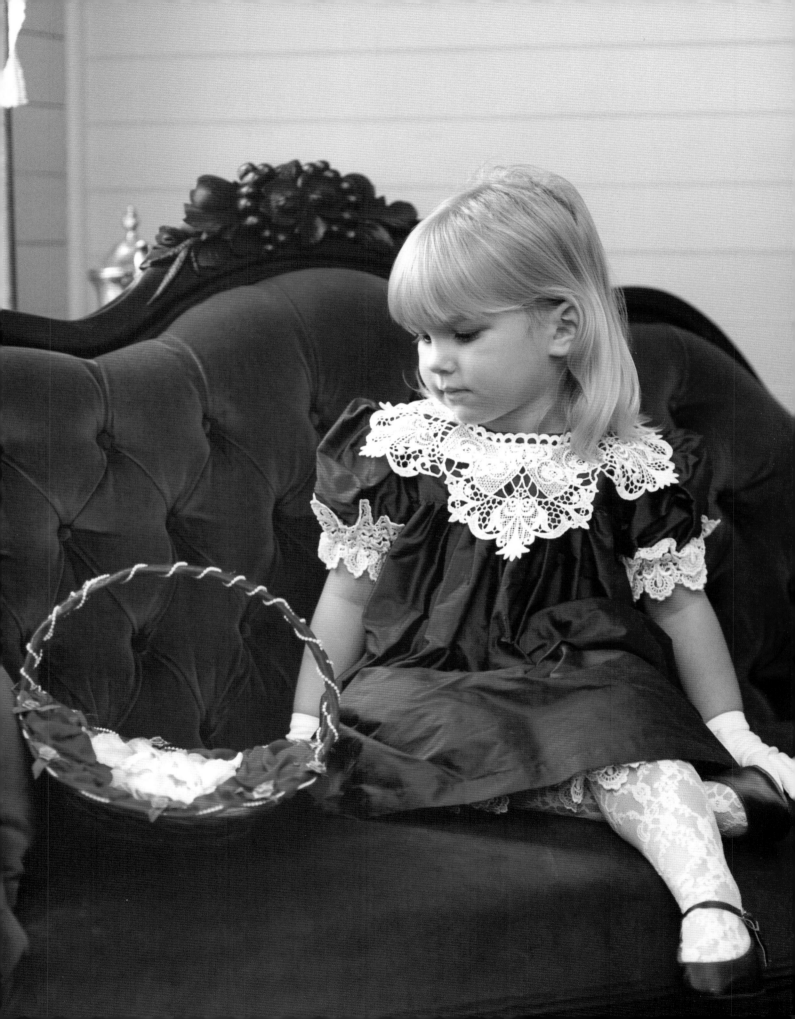

POSE. While photographing a wedding, I did a series of images of the bride and flower girl. I love working with indirect light through large windows. This window was large and had a set of vertical blinds. The blinds allowed me to control the amount of light coming through and hitting the subjects. I turned the bride slightly away from the window. This increases the texture on her gown by bringing the light across the front of it. I positioned the flower girl so that she did not cover the dress. This gave each subject her own space.

PROPS. Because the flowers are close to the light source, they are brighter than the subjects' faces. Since the flowers, and especially the bride's bouquet, are a big part of weddings, it doesn't bother me. I could have custom printed the image and burned down the flowers (burning down is a darkroom term that means to darken by allowing more light from the enlarger to fall on a certain part of the image). I also could have placed the image in an oval mat, which would cover part of the flowers.

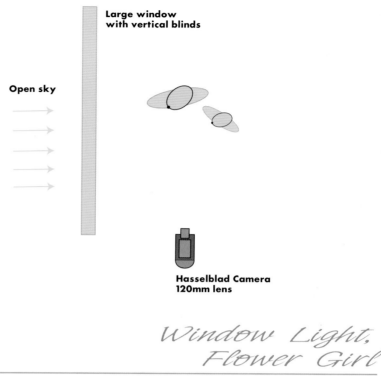

Window Light, Flower Girl

PHOTOGRAPHY. When using window light, you can increase the contrast of the light on the subjects by moving them closer to the window, and decrease the contrast by moving them away wedding lies in the relationships you build with the participants. Typically I get down on the child's level and talk to him/her about the "big job" he/she will be doing that day. If I need to

BECAUSE THIS WINDOW WAS SO LARGE, I DID NOT NEED ADDITIONAL FILL.

from it. Because this window was so large, I did not need additional fill. Look at the quality of light on the subjects' faces. The film used was Kodak PPF; exposure was $\frac{1}{30}$ second at f-4.

PSYCHOLOGY. The real beauty of photographing a have a child to look out of a window, I sometimes have his or her mom go outside. Then I instruct the child to look at mom. This gets mom out of the room, and ensures she won't be saying "Smile, honey, smile!" when I want a sensitive expression.

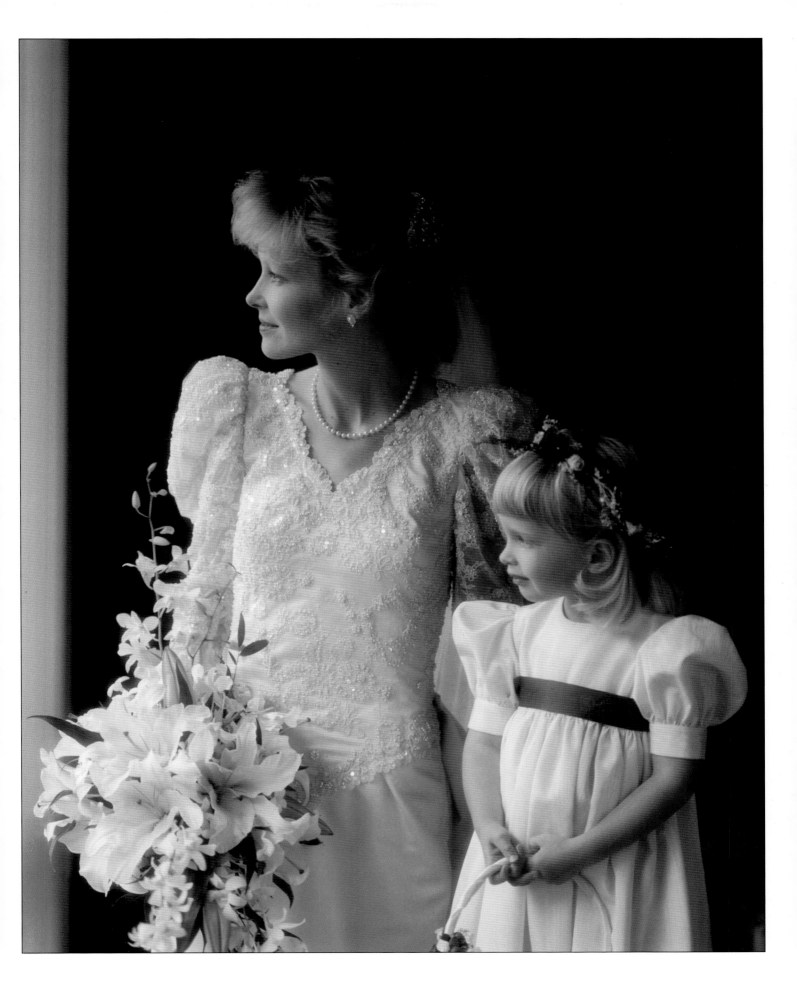

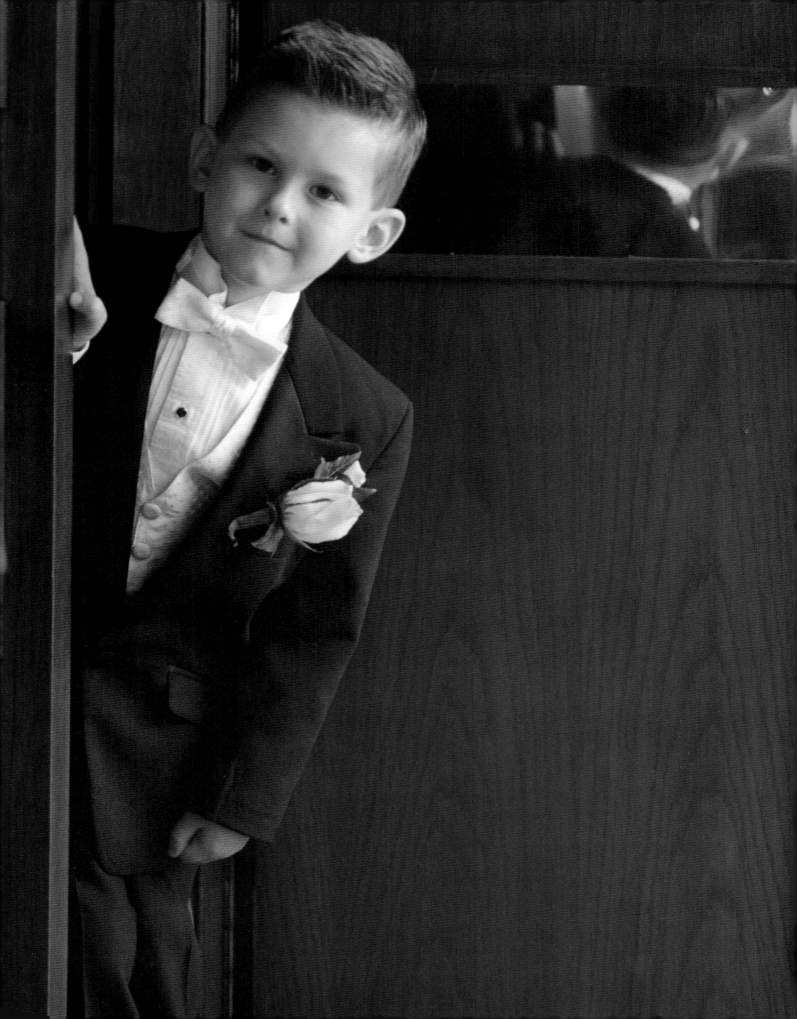

Natural or Not?

I love it when you look at images in a wedding album and you can't tell if they were photographed as they happened or if they were set up. That's the kind of image I like to create.

As for these images, what do you think? Were they natural or posed? Does it even matter? I contend that it doesn't. They are nice, natural looking images, regardless of how they were made.

To let you in on at least one secret, the photo on the facing page is a combination. I did actually see the little boy do this, but I couldn't get into the right position to get the image. Since I thought it was too good to pass up, I asked him to do it again. He did so, and the result is a cute image of this little boy with a very big flower.

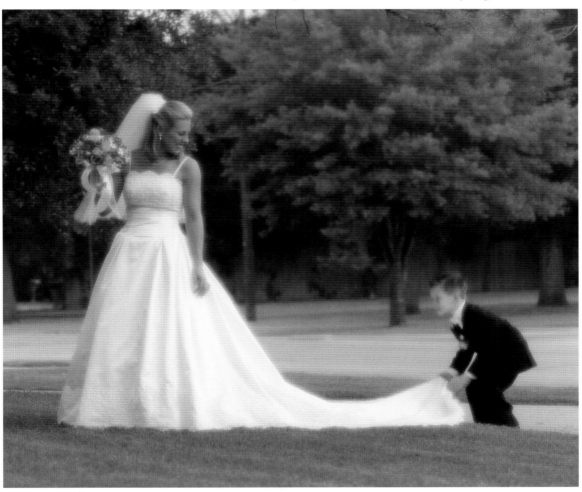

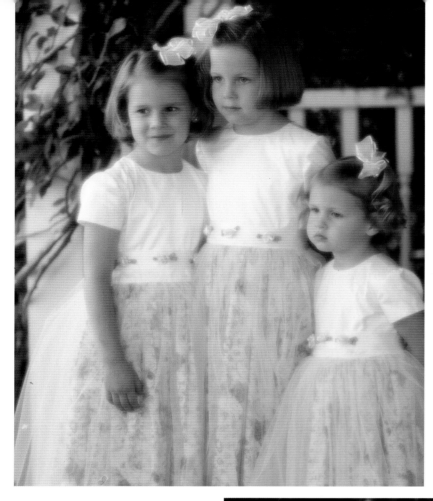

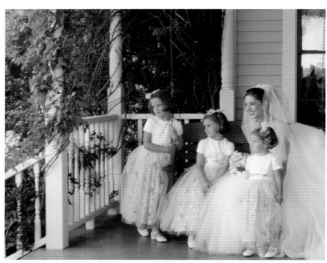

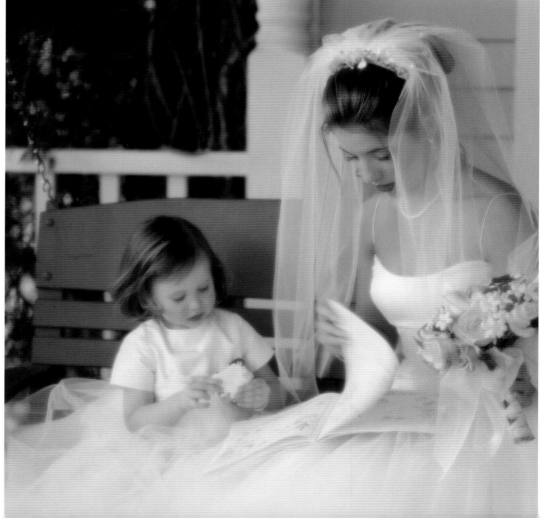

WORKING WITH CHILDREN. One of my favorite things about photographing weddings is the children. They are so much fun—and so curious! If children are shy, they can require a lot of work. When everything goes right, though, you get fantastic images and everyone commends you for how well you handle the children.

When I am working with children at weddings I like to have fun with them. The best trick I've learned for

Three Flower Girls

brought the other two girls together around her and had them squeeze in together.

For the portrait of the girls with the bride, I had the bride sit on the porch swing. He dress was pulled up in the back so that only

The portrait of the bride reading a book with the single flower girl actually began simply as a way to keep the girls occupied. As luck would have it, the activity turned into a wonderful portrait of the pair.

WHEN I AM WORKING WITH CHILDREN AT WEDDINGS I LIKE TO HAVE FUN WITH THEM.

winning over the kids is to ask them to "Give me five." I let the child slap my hand, and no matter how hard or soft they do it, I say "Ow!" The first time I say this they usually look puzzled. The second time they smile, and every time after that they laugh! In fact, for the rest of the day I usually have children following me around saying "Can I give you five?"

POSING. I wanted a very natural look for the portrait of the three little flower girls (top, left). To create a triangular composition, I posed the tallest girl first. Then I

her petticoats touched the bench, ensuring her dress wouldn't get dirty. I then gathered the girls around the bride and asked them all to look out toward the steps. I love how the oldest girl is leaning in and has her foot up.

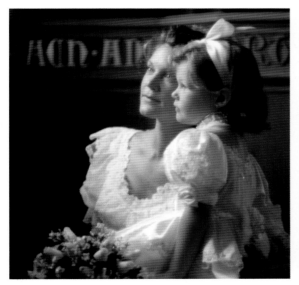 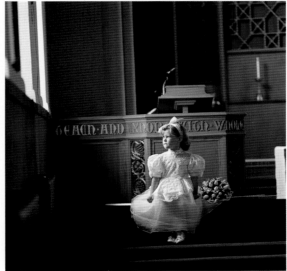

Here we see three variations, photographing a little girl and the bride in natural window light.

LIGHTING. For the first portrait (above, right), I placed the girl on top of the piano in the church. This put her in the light I wanted for the

you see less of this side of the face, it is called the short side).

In the other two images (facing page and above, left), I photographed the girl in a back profile. This simply means that exactly half of her face is showing and her back is toward the camera.

For the final portrait (above, left), I brought the bride into the frame and placed her in front of the girl. With both subjects looking into the window, the effect of the light is simple and flattering.

EXACTLY HALF OF HER FACE IS SHOWING AND HER BACK IS TOWARD THE CAMERA.

portrait. I had the girl look into the light to achieve a ⅔ view with a short lighting pattern on her face. This simply means that the light is stronger on the side of the face that is turned toward the light source (because

CHILDREN'S STORYBOOK

Sometimes I do a session with the goal of capturing one specific image—I'm looking for something nice to hang on the wall, an art piece or a design piece as an accessory for a room. Other times I want to tell a story and capture a special time in a child's life. That is the case with this storybook-style series. The little girl's mom was going to have a new baby soon. We wanted to capture this stage in the little

OTHER TIMES I WANT TO TELL A STORY AND CAPTURE A SPECIAL TIME IN A CHILD'S LIFE.

girl's life and the things happening to her before the new baby arrived.

This series was created by my wife Barbara and I. Barbara used the Nikon 8008S and Kodak T-Max 400 CN film. This new film by Kodak produces wonderful black and white images. The beauty of the film is that it is developed in regular color chemistry. That means that any local or one-hour lab can process and print the film. This saves you money and time. It is also quite versatile: it can be printed in a rich brown tone, a cool blue tone, or traditional black and white. The black and white prints have a selenium-toned look that is very pleasing.

I used the T-Max 400 CN rated at ISO 400 in the medium format size. Many of the images I did and all of the images Barbara did were done with available light. With Barbara's film, we used a technique called "pushing," in which the ISO (film speed) is set to a higher rating than the film is normally rated for. In this case we chose ISO 1250. This allowed Barbara to handhold the camera and use a sufficiently high shutter speed to prevent camera movement problems. When the film is finished, the film is taken to the lab to be push-processed; make sure to let the lab technician know what speed you used to expose the film.

Push-processing film typically increases the grain and contrast (see the image "Tender When I Want To Be" on page 96), an effect that many people find very appealing. I have included images from both my camera and Barbara's.

I really enjoy having two camera systems and two photographers shooting our storybook sessions. It gives two different perspectives to the story and to the photography. The Nikon is an amazing piece of equipment. Its automatic averaging mode takes care of the technical side of photography and allows Barbara to concentrate on the artistic and storytelling aspect of the session.

In creating a storybook album, your creativity as a photographer can really flourish. Since the format

employs a number of images used in combination to tell a story. Words, poems, titles, and even quotes from a child can be incorporated into the album, rounding out the package beautifully. The final product is designed as a coffee-table style album. Be creative in coming up with themes and stories. Also, be sure to work with the moms and get their input.

The album we use is made by Art Leather (see the resources section at the back of this book). They make several styles and sizes that

Here are just a few themes you might use to help you shape your own storybooks:

- Losing the First Tooth
- The First Birthday
- The First Haircut
- A Trip to the Zoo
- A Day at the Beach
- Visiting Grandmother
- The New Puppy
- The New Baby

The images and text on the following pages are taken from a storybook session called "The New Baby!"

WORDS, POEMS, TITLES, AND EVEN QUOTES FROM A CHILD CAN BE INCORPORATED INTO THE ALBUM.

will work for the storybook collection. My favorite is called Mezzo.

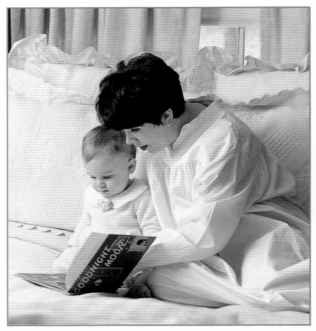

Once upon a time, there was a wonderful young girl. She lived at home with her mommy, daddy, and her dog, Sally.

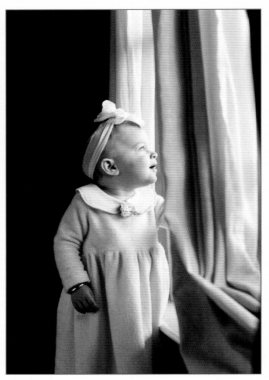

Very, very soon someone new was going to arrive at her home.

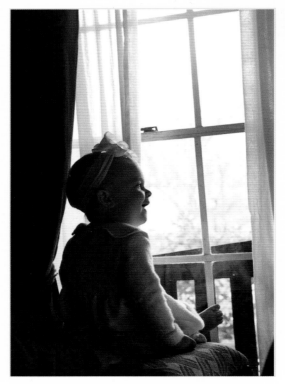

She didn't quite understand how the new person would arrive, but everyone told her it would be soon!

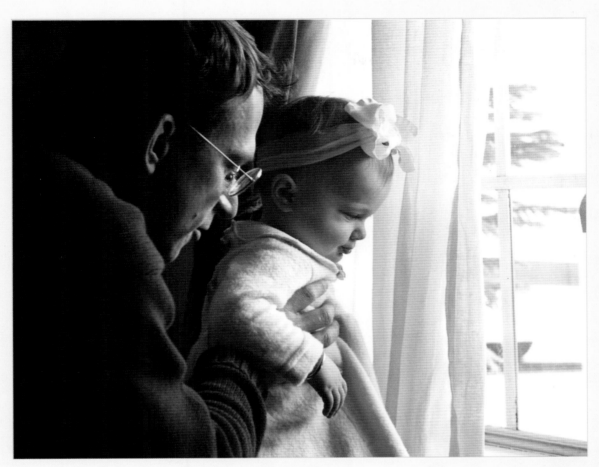

Mommy and Daddy were very excited!

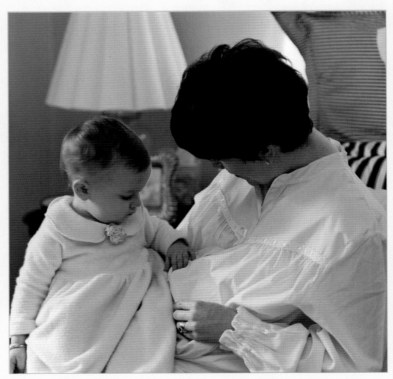

What confused her most was that mommy's tummy was growing.

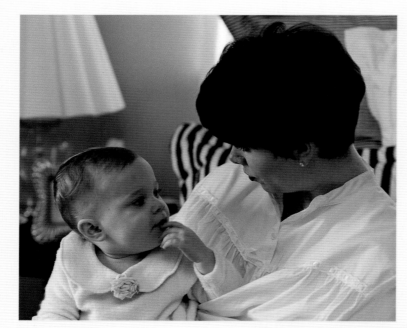

Mommy said the new baby was in her tummy. In her tummy?

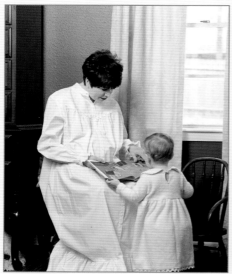

I like when Mommy reads me stories about babies.

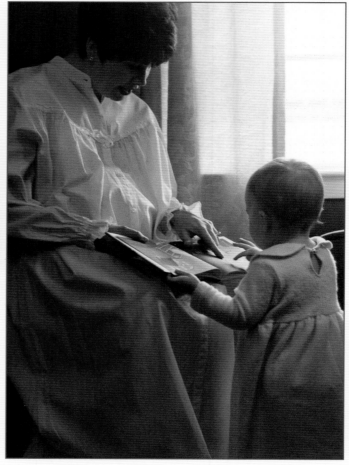

That baby looks just like me!

Sally, the baby will have a nose and eyes and ears.

Do you think the baby's feet will look like mine or yours?

I think they will look like mine!

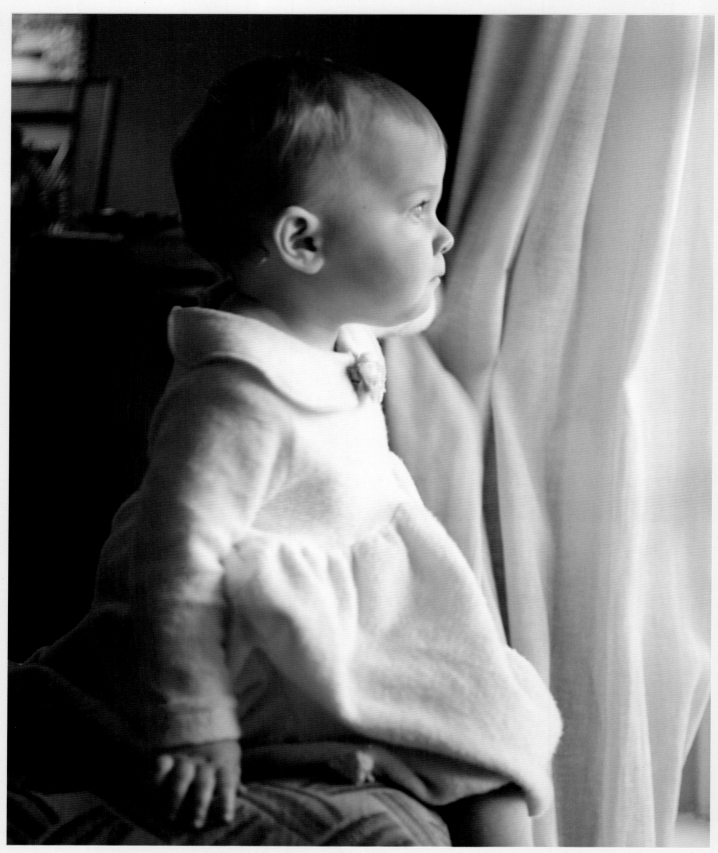

I can't wait! I hope the baby comes soon!

APPENDICES

Children's Portrait Guidelines

This is a handout that I provide to clients to help them plan for their portrait session.

Several factors are important in creating beautiful children's portraits: location, clothing selection, and lighting. I will take care of the lighting. Together we will discuss the location and find the best place to create the portrait. Clothing selection is your department. It is one of the most important factors in portraiture.

Usually, simple clothing photographs best. Avoid bold patterns and bright colors. I believe the clothing should reflect the personality of the child. We will assist you in picking the best clothing for the portrait. We have assembled a collection of "proper" clothing samples to aid you in this task. Hats make great accessories for children, but don't put the hat on until we have had time to do some hatless images. Put as much thought into shoes as you do with the rest of the outfit. When I photograph small children, their shoes often show in the photographs. Little bare feet have a lot of personality. I often like to photograph them.

I do a lot of children's portraits in their own rooms. Relax, moms—the whole room does not have to be perfectly clean. Many times a small corner, perhaps a window or the child's bed, is all we need. The best thing about photographing in the child's own room is they feel comfortable there. Also I can use the child's own toys, books, and other personal items in the portraits. All of these factors give security, add to the personalization of the portraits, and will add to your enjoyment for many years to come.

Smiles are beautiful on children, especially on close-up images. Soft expressions are especially good with the more sensitive or reflective portraits. Please don't instruct children to say silly words like "cheese" or tell them to smile for Mr. Box.

Natural expressions, soft smiles, and spontaneous looks on children make for enduring portraits.

Children usually do best when siblings or relatives are not brought along for the portrait session. Extra people can be distracting and could hurt the portrait.

When scheduling your portrait session, keep in mind that the most flattering light occurs during the last hour of daylight. The second best time is the first hour of the day, however, because it is so early, some children may not do as well at this time. Another consideration in scheduling the time is the child's routine. When does he usually nap or rest? What is his normal time to eat?

If you feel your child is very shy or takes a while to warm up to strangers, we can schedule something I call playtime. You can bring the child to the studio a day or two before the session to meet with Mr. Box and play

with all of his toys. Or, if we are doing the portrait at your home, I can stop by there and have this playtime. This will give me a chance to meet with your child. It will also give me time to look around to find the best place for the portrait.

In order to ensure the best possible portraits, it is important that the session not be rushed. Depending on how your child reacts, we may spend as little as thirty minutes or as long as an hour or two creating the images. Many times the first ten to fifteen minutes are just "get acquainted" time.

Sometimes it is good to have a parent in the room during the session, sometimes it is not. Many times I will start with the parent in the room and let them quietly slip out during the session.

If you feel that your child is not in the proper mood for the portrait or is not feeling well, don't hesitate to call so that we can reschedule the session.

The Next Step: Senior Portraits

When does a child become a young adult? Maybe it's when they become high school seniors. How is photographing seniors different from photographing children? In many ways it's not. The lighting techniques and camera methods are the same, and background selection is very similar. Primarily, the differences are in posing, prop selection and—above all—psychology.

Seniors want to be different, but not *too* different. The answer is to have a large variety of props and backgrounds to choose from. Then you can let the combinations of these make each image unique.

The most important aspect of senior photography is to show the different aspects of the subject's personality. Show their fun side, their serious side, the activities they enjoy and the clothing they like to wear. Typically, I do 20–30 different poses of a senior with 4–5 clothing changes. Typical clothing selections include:

- Something dressy (prom gown, suit and tie, etc.)
- A classic casual outfit that will look good for years to come
- Something that's "them" (a wild or cool outfit)
- An outfit that shows a favorite activity (sports uniform, perhaps a costume for a senior who's involved with theater, or even casual clothes for a portrait with their car or truck)

- Cap and gown (or tux jacket, or drape, depending on the tradition of their school)

I also encourage students to bring their own props—things that will remind them of their years in school. These could include trophies, sporting equipment, a pet, a favorite book or even a car. Some students even bring a friend or sibling. One popular image we do is

called "The Gang" where we have seniors bring all their favorite people to be photographed together. We've had as many as 25 people for one photograph!

My favorite type of photographs are what I call "environmental portraits." These should be custom, hand-crafted works of art that can be hung next to other artwork in the finest homes. Through the selection of setting, it should reveal something about the person being photographed. A successful environmental portrait should also demonstrate good design, natural posing, color harmony and a good expression. Though many photographers use the word "environmental" only for portraits created outdoors, I would expand the

MY FAVORITE TYPE OF PHOTOGRAPHS ARE WHAT I CALL "ENVIRONMENTAL PORTRAITS."

term to include any portrait made on location—whether outdoors, in the office, or in the client's home.

The most important factor is memories. My own senior portraits (done in 1971) consisted of two photographs, one of me in a suit, and the other in a cap and gown. Neither showed my

personality, my style, my interests, or what made me distinctive. I want to give more to the seniors I photograph. I want them to be able to look at the photographs—especially five, ten or twenty years from now—and remember what was going on at that period in their lives.

Resources

THE AUTHOR

The author is also available for personal and small group consultations in the areas of

- Children's photography
- Wedding photography
- Family photography
- High school senior photography
- General business operations

For more information on Doug Box's current speaking and/or workshop schedule, please contact:

dougbox@aol.com
www.dougbox.com
www.simplyselling.com

ORGANIZATIONS

Professional Photographers of America
229 Peachtree Street
International Tower
Atlanta, GA 30303
(404)522-8600
www.ppa.com

Wedding and Portrait Photographers International
PO Box 2003
Santa Monica, CA 90406
www.wppi-online.com

SUPPLIERS

Cameras
Hasselblad 500 CM
Major lenses 120mm, 150mm, 250mm
Hasselblad USA
10 Madison Road
Fairfield, NJ 07004
(973)227-7320
www.Hasselblad.se

Nikon 8008S
Nikon
1300 Walt Whitman Road
Melville, NY 11747
(800)NIKON US
www.nikon.com

Meters
Minolta IIIf with the optional flat disk
Minolta USA
(201)825-4000

Sekonic L508 Zoom Meter
Sekonic USA
(914)347-3300

Modular Belt and Case System
Kinesis Photo Gear
5875 Simms St.
Arvada, CO 80004
(435)462-2266
www.kinesisgear.com

Tripod
Bogen 3050, 3021,

Bogen camera stand
Bogen Photo Corp.
565 E. Cresent Ave.
Ramsey, NJ 07446
(201)818-9500
www.manfrotto.it:80/bogen/

Children's Storybook Albums
Art Leather
(888)AL-ALBUMS

Chairs and Other Props
American Photographic Resources
(800)657-5213

Film
Eastman Kodak PPF, VPS, VPH, TXP
TMZ, T-Max 400 CN, Ektalure G Paper
(800)657-5213
www.kodak.com

Lighting Equipment
Larson Enterprises
Orem, UT
(801)225-8088

Photogenic Flash Master, Power Lights, Umbrellas, Silver Reflector
Photogenic Professional Lighting Co.
(800)682-7668

Quantum
1075 Stewart Avenue
Garden City, NY
(516)222-6000
www.qtm.com

Visatec Lights
10 Madison Road
Fairfield, NJ 07004
(973)227-7320
www.hasselblad.se

Painted Backgrounds
Les Brandt Backgrounds
(800)462-2682

Props
American Photographic
Resources
Randy and Patty Dunham
PO Box 820127
Ft. Worth, TX 76182
(817)431-0434

EDUCATION
Simply Selling
Business Audio Tape Series
PO Box 1120
Caldwell, TX 77836
Fax (979)272-5201
www.simplyselling.com

Photo Vision
A Video Magazine
15513 Summer Grove Court
North Potoman, MD 20878
Fax (301)977-2676
(888)880-1441
www.photovisionvideo.com

Many of the films originally used to create the images discussed in this publication have been upgraded. The new films I use are the Kodak Portra films. If I want a little more snap or contrast, I use Kodak Portra VC 400 (VC stands for Vivid Color). For a more natural contrast, I use Kodak Portra NC (NC stands for Natural Color).

I also use Kodak Portra B&W. This is a C-41 film, which means it is processed in color film chemistry and printed on color film paper, but gives you a black & white image. I've found that this film yields beautiful blacks and whites and a great tonal range.

Also by Douglas Allen Box . . .

PROFESSIONAL SECRETS OF WEDDING PHOTOGRAPHY, 2nd Ed.

Top-quality portraits are analyzed to teach you the art of professional wedding portraiture. Lighting diagrams, posing information, and technical specifications are included for every photograph. $29.95 list, 8½x11, 128p, 80 color photos, order no. 1658.

PROFESSIONAL SECRETS OF NATURAL LIGHT PORTRAIT PHOTOGRAPHY

Use natural light to create hassle-free portraiture that brings out the very best in your clients. This beautifully illustrated book provides detailed instructions on equipment, lighting, posing, and much more. $29.95 list, 8½x11, 128p, 80 color photos, order no. 1706.

By Barbara Box . . .

STORYTELLING WEDDING PHOTOGRAPHY

Barbara and her husband shoot as a team at weddings. Here, she shows you how to create outstanding candids (her specialty) and combine them with more traditional formals (her husband's specialty) to create stand-out wedding albums. $29.95 list, 8½x11, 128p, 60 b&w photos, order no. 1667.

BEGINNER'S GUIDE TO ADOBE® PHOTOSHOP®, 2nd Ed.

Michelle Perkins

Learn to effectively make your images look their best, create original artwork, or add unique effects to any image. Topics are presented in short, easy-to-digest sections that will boost confidence and ensure outstanding images. $29.95 list, 8½x11, 128p, 300 color images, order no. 1732.

PROFESSIONAL TECHNIQUES FOR DIGITAL WEDDING PHOTOGRAPHY, 2nd Ed.

Jeff Hawkins and Kathleen Hawkins

From selecting equipment, to marketing, to building a digital workflow, this book teaches how to make digital work for you. $29.95 list, 8½x11, 128p, 85 color images, order no. 1735.

LIGHTING TECHNIQUES FOR HIGH KEY PORTRAIT PHOTOGRAPHY

Norman Phillips

Learn to meet the challenges of high key portrait photography and produce images your clients will adore. $29.95 list, 8½x11, 128p, 100 color photos, order no. 1736.

PROFESSIONAL DIGITAL PHOTOGRAPHY

Dave Montizambert

From monitor calibration, to color balancing, to creating advanced artistic effects, this book provides those skilled in basic digital imaging with the techniques they need to take their photography to the next level. $29.95 list, 8½x11, 128p, 120 color photos, order no. 1739.

LIGHTING AND EXPOSURE TECHNIQUES FOR OUTDOOR AND LOCATION PORTRAIT PHOTOGRAPHY

J. J. Allen

Meet the challenges of changing light and complex settings with techniques that help you achieve great images every time. $29.95 list, 8½x11, 128p, 150 color photos, order no. 1741.

TONING TECHNIQUES FOR PHOTOGRAPHIC PRINTS

Richard Newman

Whether you want to age an image, provide a shock of color, or lend archival stability to your black & white prints, the step-by-step instructions in this book will help you realize your creative vision. $29.95 list, 8½x11, 128p, 150 color and b&w photos, order no. 1742.

THE BEST OF WEDDING PHOTOGRAPHY

Bill Hurter

Learn how the top wedding photographers in the industry transform special moments into lasting romantic treasures with the posing, lighting, album design, and customer service pointers found in this book. $29.95 list, 8½x11, 128p, 150 color photos, order no. 1747.

PROFESSIONAL PHOTOGRAPHER'S GUIDE TO
SUCCESS IN PRINT COMPETITION

Patrick Rice

Learn from PPA and WPPI judges how you can improve your print presentations and increase your scores. $29.95 list, 8½x11, 128p, 100 color photos, index, order no. 1754.

PHOTOGRAPHER'S GUIDE TO
WEDDING ALBUM DESIGN AND SALES

Bob Coates

Enhance your income and creativity with these techniques from top wedding photographers. $29.95 list, 8½x11, 128p, 150 color photos, index, order no. 1757.

THE BEST OF PORTRAIT PHOTOGRAPHY

Bill Hurter

View outstanding images from top professionals and learn how they create their masterful images. Includes techniques for classic and contemporary portraits. $29.95 list, 8½x11, 128p, 200 color photos, index, order no. 1760.

THE BRIDE'S GUIDE TO WEDDING PHOTOGRAPHY

Kathleen Hawkins

Learn how to get the wedding photography of your dreams with tips from the pros. Perfect for brides (or photographers preparing clients for their wedding-day photography). $14.95 list, 9x6, 112p, 115 color photos, index, order no. 1755.

DIGITAL PHOTOGRAPHY FOR CHILDREN'S AND FAMILY PORTRAITURE

Kathleen Hawkins

Discover how digital photography can boost your sales, enhance your creativity, and improve your studio's workflow. $29.95 list, 8½x11, 128p, 130 color images, index, order no. 1770.

LIGHTING TECHNIQUES FOR
LOW KEY PORTRAIT PHOTOGRAPHY

Norman Phillips

Learn to create the dark tones and dramatic lighting that typify this classic portrait style. $29.95 list, 8½x11, 128p, 100 color photos, index, order no. 1773.

THE BEST OF WEDDING PHOTOJOURNALISM

Bill Hurter

Learn how top professionals capture these fleeting moments of laughter, tears, and romance. Features images from over twenty renowned wedding photographers. $29.95 list, 8½x11, 128p, 150 color photos, index, order no. 1774.

THE DIGITAL DARKROOM GUIDE WITH ADOBE® PHOTOSHOP®

Maurice Hamilton

Bring the skills and control of the photographic darkroom to your desktop with this complete manual. $29.95 list, 8½x11, 128p, 140 color images, index, order no. 1775.